# REMBRANDT
# BY REMBRANDT

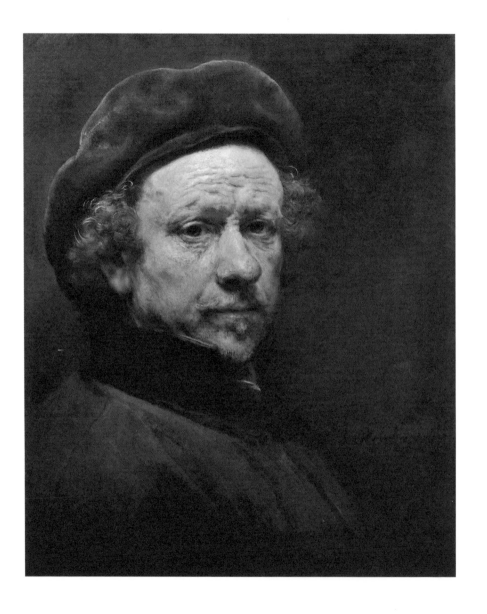

# REMBRANDT BY REMBRANDT

## THE SELF-PORTRAITS

Pascal Bonafoux

ABRAMS, NEW YORK

# CONTENTS

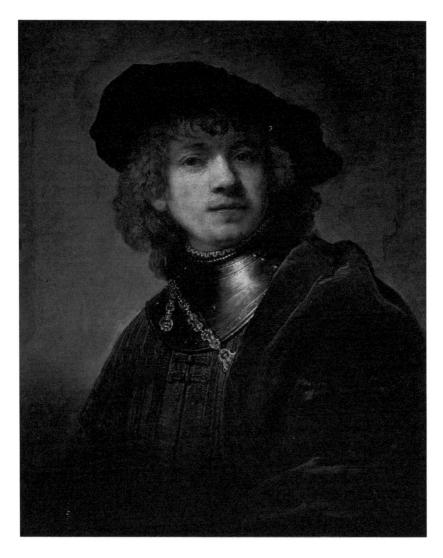

*Self-Portrait as a Young Man*. (1634). Oil on panel, 61 × 52 cm.
Traces of a signature: ... *f*. Uffizi Gallery, Florence.

# 1. PAINTER OF TIME?

Why did Rembrandt engrave, draw, and paint portraits of himself? To paint time? Rembrandt only paints the present of his face. Here and now. Any portrait is a suspension of time. The succession of Rembrandts is a series of examples of time stopped; they have no duration. (Their frequency invents an arbitrary, irregular fiction.) To paint is to try to keep time at bay.

These pages are neither a monograph nor a biography. There is no portrait of, say, *Rembrandt Bankrupt* or *Rembrandt the Widower*. Rembrandt, painter without a patron, was, first of all, looking for commissions. The portraits he painted of himself were intended for his studio, for those students around him who were being introduced to painting, and perhaps even for a privileged few who commissioned their own portraits. How could they not be impressed and reassured by an excellent portrait of *their* painter, in whom they had placed their trust when his fame was still precarious?

What did these models who came to the studio expect from their long hours of posing? Something palpable that served them, displayed their rank, and made them memorable for posterity. A portrait is vanity posing in front of ambition.

Rembrandt was ambitious, vain, solemn, and very soon alone. It was only with himself as a model that he would not betray painting. His arrogance was transmuted into discipline. He showed no care for the flattering resemblance and respectability his clientele demanded. He was intractable and uncompromising, even cruel. Painting himself left him free to be implacable: to hunt down a shadow that deepened a wrinkle, the asymmetry of the eyebrows, the furrows that descended from the nose to the corners of the lips; to let the line and brushstroke break free from the factual; to seek the depth of shadow, of light; to attempt other relationships of planes, low-reliefs, and masses of a head. To paint oneself must be to experience oneself quite intensely. A tête-à-tête of this kind—how to imagine it, describe it, tell the story?

Ambition taunts him. His pride manifests as humility. He cannot escape their inexorable demands.

What follows is a record of this incomparable undertaking.

# 2. THE SOUL

An exhibition in Paris in 2016–2017 brought together some of Rembrandt's works. As expected, a magazine reported on it: "In Rembrandt, the face is the reflection of the psyche and the soul. He is the only painter to have scrutinized his own face more than eighty times throughout his life, in painting and etching; from the young man who started in Leiden at nineteen to the old man of sixty-three (an age that is equivalent to more than eighty years today), worn out by material worries and grief. The same man over a period of more than forty years. The intimate diary of a lifetime." According to another article in another weekly: "This extraordinary Dutch Baroque artist, a contemporary of Rubens, is rightly considered as the best *painter of the human soul* who has ever existed."

"Painter of the human soul"—in italics, no less, without the slightest hesitation. And again, yet another declares, "Rembrandt is the painter of the secret of souls." Not only does he paint souls, but he paints the secret of these souls! How in the world did he manage it? Because, as another article confirms, "Undisputed master of chiaroscuro, his light is like a revelator of the soul."

Are these words anything more than mediocre, commonplace, insignificant clichés that signal a dereliction of looking and thinking? When, where, and in which studio did a "soul" ever pose for a painting?

Marten Looten, Maurits Huygens, Johannes Wtenbogaert, Aelbert Cuyper, Cornelia Pronck, Amalia van Solms, Willem Burggraeff, Jan Krul, Maria Bockenolle, Philips Lucasz, Antonie Coopal, Maria Trip . . . must we list again the names of all those who commissioned their portraits from Rembrandt? Who among them asked him not to forget to paint his or her soul? To whom did he promise to reveal the secrets of their psyche? Consider the possibility that any of them had read this line in Jean de La Fontaine's fable "The Wallet": "We see ourselves with another eye than our neighbors do." Perhaps the more discerning hoped that finally, thanks to Rembrandt, who saw them with "another eye," face-to-face with their finished portrait they would finally know themselves.

And the soul? Pastors, ministers, rabbis, and priests of all religious denominations would exclaim with one voice that finally they could see the soul! Blessed be Rembrandt!

To those with such hopes, the following pages can only cause bitter disappointment: The soul of Rembrandt remains obscure and mysterious.

*Self-Portrait*. c. 1659. Oil on wood, 30 × 23 cm (RRP, 30.7 × 24.3 cm). Musée Granet, Aix-en-Provence.

# 3. FIRST APPEARANCE

In the catalogue raisonné of Rembrandt's paintings, a new version of which Horst Gerson published in 1968, he admits no more than 420 works as worthy of being attributed to Rembrandt (Abraham Bredius's, a few decades earlier, included 639). Among them is *The*

*The Stoning of Saint Stephen*. 1625. Oil on wood, 89.5 × 123.6 cm.
Signature and date: *Rf 1625*. Musée des Beaux-Arts, Lyon.

*Stoning of Saint Stephen* (opposite). Since the publication of a study by Gerson, who first recognized the hand of Rembrandt in this work, in a 1962 issue of *Bulletin des musées et monuments de Lyon*, nobody has questioned this authentication. This painting, an oil on panel, is one of the 348 collected in *A Corpus of Rembrandt Paintings* published in 2014 by the Rembrandt Research Project. It is the first work that we know of from him, painted when he was nineteen or twenty years old. It is signed and dated, *R f. 1625*. "R" for Rembrandt, "f" for *fecit* in Latin ("he made [it]").

The Acts of the Apostles (6:8–9 and 7:57–59) recounts the stoning of Saint Stephen: "Members of the Synagogue of the Freedmen (as it was called)—Jews of Cyrene and Alexandria as well as the provinces of Cilicia and Asia . . . covered their ears and, yelling at the top of their voices, they all rushed at him, dragged him out of the city and began to stone him. Meanwhile, the witnesses laid their coats at the feet of a young man named Saul. While they were stoning him, Stephen prayed, 'Lord Jesus, receive my spirit.' Then he fell on his knees and cried out, 'Lord, do not hold this sin against them.'"

In his treatise *On Painting*, Leon Battista Alberti wrote: "I will say what I myself do when I paint. First I trace as large a quandrangle as I wish, with right angles, on the surface to be painted; . . . it functions for me as an open window through which the historia is observed, and there I determine how big I want men in the painting to be." In Book II, he specifies: "The great work of the painter is . . . a historia." The supremacy of "historia," or history painting, was indisputable and unchallengeable throughout Europe (for some, even into the nineteenth century). Rembrandt had to have embraced this dogma. It is on a "quadrangle, with right angles," portraying an episode from the Acts of the Apostles, that he turned to history for the first time. And history did not stop being his model until 1669, the year of his death.

Because painting history was the surest way to be counted among the most important painters, it was the shortest route to fame. To prove that one was able to paint history is the guarantee required by those who commissioned their portraits.

Also, it would not have been irrelevant for those same potential patrons to recognize Rembrandt himself in the face above that of Saint Stephen, raising his eyes to the heavens. Rembrandt's head is framed by the raised arms of the men who are about to throw stones at the first Christian martyr.

# 4. HISTORY PAINTING

Rembrandt is here, his face partially blocked by a raised scepter (opposite). What historical event is he participating in? Is this an episode recounted by one of the historians of Greek or Roman antiquity or by a text of the Old or New Testament?

Hypotheses abound. Is it the clemency of Titus or that of the Consul Cerialis, or maybe the sentencing of Lucius Junius Brutus, or the condemnation of the son of Manlius Torquatus? Could it be the pardon that Tacitus mentions in the *Annales* with these words: "And the Roman general did not consider revenge"? Or is the kneeling young soldier Jonathan, son of Saul, who appears before his father after the battle of Ayalon, where the Philistines of Micmas were defeated? This man who is waving the scepter, could he be Saul, and are these meant to be the people crying out for Jonathan to be saved? ("By the life of Yahweh, not a hair of this head shall fall to the ground.") Neither weapons, nor costumes, nor architectural elements in the distance give any clues. Is that sheeplike animal on the top of the column the she-wolf of Rome? Impossible to know.

Another possibility? In Chapter XVII of Book IV of *Histories*, which he finished in 106 CE, Tacitus reports at length about a battle won over the Romans by the Batavians, "the first of all peoples for their bravery" who "occupy a modest part of the riverbank, but especially an island of the Rhine." After this victory, Tacitus says, "Their fame was great in Gaul and Germany," where they were celebrated as liberators. Germany sent at once to offer them help; as for Gaul, [Batavian leader Gaius Julius] Civilis used skill and gifts to win its allegiance, returning to their homeland the prefects of captive legionaires, giving the captives themselves the choice to stay or return." The historian continues, "Those who remained had a position of honor in the army; we offered to the others a part of our plunder." This "plunder," under the pen of a Roman, refers to the booty abandoned by the Imperial legions. Tacitus's evocation of the courage and magnanimity of Civilis may offer the most coherent explanation of the work we see.

One objection: Tacitus describes Civilis as "more cunning than the common barbarians, and who compared himself to Hannibal and Sertorius, because he had the same

*Ancient Scene* or *The Old Testament* (sometimes called *Cerialis and the Germanic Legions*). 1626. Oil on wood, 90.1 × 121.3 cm. Stedelijk Museum De Lakenhal, Leiden.

scar on his face." Civilis, like Sertorius, was one-eyed; an older Rembrandt portrayed him with the disfigurement in a later work. Here, the head of the personage supposed to depict him is turned so that a shadow covers half his face. A cautious, artful trick? Perhaps. The resistance to Roman power of the Batavians, viewed as distant progenitors of the Dutch, inspired the latter in their wars against Spain, and it is only a year since the surrender of the nearby city of Breda, where the troops of Justin of Nassau, deprived of reinforcements and food by the siege, capitulated to the Spanish forces on June 5, 1625 (when, as famously depicted in a painting by Diego Velázquez, it was the Genoese Ambrogio Spinola in the service of Spain under Philip IV who paid homage to the defeated Dutch). It would have been inopportune for Rembrandt, at twenty, to be accused of sacrilege for having highlighted the infirmity of the ancient hero who came to end Roman oppression and who was an example for those who would overthrow that of Spain.

And yet one more hypothesis. Rembrandt's composition appears to be a variation of the Coriolanus painted by Pieter Lastman in 1625. A few months earlier, when Lastman was in Amsterdam, did his pupil, Rembrandt, see his master sketch this painting, whose subject came from the "Life of Coriolanus" in the *Illustrated Parallel Lives* of Plutarch? Uncompromising, implacable Coriolanus, who threatens Rome with the Volscians who have risen up against the city, agrees to withdraw his army after receiving a delegation of Roman women led by his own mother, Veturia. Compare the works. Same powerful man dominating the scene. Same number of figures around him. Same sky behind raised spears and halberds. Same weapons on the steps—on one step is a helmet, and on the other are pieces of armor and a shield. Same groups kneeling at the foot of the platform— women on one side and men on the other. Same light that, in both paintings, falls from the top left, etc. But the essential difference is, we know what the Lastman painting is about, and we do not know what Rembrandt is depicting. Is this a result of the clumsiness of a painter who only wants to assert that he, too, can paint history, or is this a deliberate choice to invite the viewer to focus primarily on the mastery of painting rather than on the subject? Neither the look of the beardless Rembrandt with tousled hair nor the presence of his face, behind the scepter held by the central figure, answers these questions.

# 5. MUSICAL COMPANY

What did anyone in Leiden in 1626 know about a fourteen-year-old sultan, Murad IV, who had reigned over the Ottoman Empire for three years? What did they know about Kösem, his mother, who provided a kind of regency? Probably very little or nothing at all. The ships of the United East India Company—the *Vereenigde Oost-Indische Compagnie*— founded in 1602, did not cross the Mediterranean, unlike the galleys of the Serenissima Republic of Venice. On the open seas, the Dutch faced the rivalry and hostility of the Portuguese, Spanish, and English fleets, but no longer that of the Turks, so they could afford to indulge their thrilling curiosity about the Ottoman Empire.

A few years earlier, in 1586, a book had been published in Antwerp, its comprehensive title: *Speech and true history of navigations, wanderings and trips made in Turkey by Nicolas de Nicolay Dauphinoys, Lord of Arfeuille, valet & ordinary geographer of the King of France, containing several singularities that the author has seen and observed, with many beautiful & memorable stories that have happened in our time, plus natural figures, both men and women according to the diversity of nations, their bearing, manners, clothes, laws, religion & way of life, both in peace and war. In Antwerp, at Arnould Coninx, MDLXXXVI.* Which of all the stories, facts, and deeds collected in its pages made their way to the northern provinces of the Netherlands that had risen up against Spain, to intensify the fascination tinted with fear provoked by the Sublime Porte of the Ottoman Empire?

The turban on this mustachioed man, who is seated with a dagger slipped into his belt, playing the viola da gamba, is a sign of this fascination. But this does not make it possible to determine the subject of the painting (page 16). To list the elements that compose it is simply to identify the pieces of a puzzle.

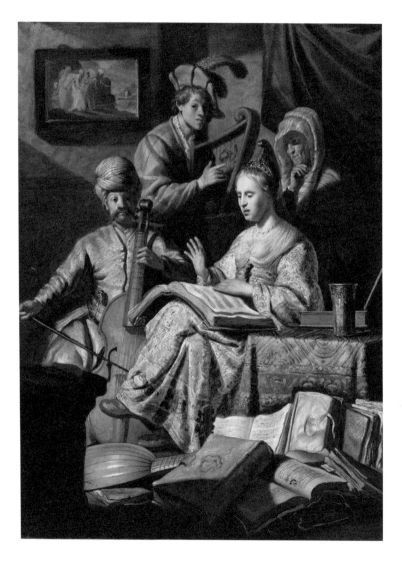

*Musical Company*. 1626. Oil on wood, 63.5 × 48 cm (RRP, 63.4 × 47.6 cm).
Signature and date: *RHL 1626*. Rijksmuseum, Amsterdam.

What does the painting hanging on the wall represent? Lot with his daughters flee-ing Sodom and Gomorrah? An uncertain hypothesis. Who is this old woman who seems to listen, hand on her chin, and whose head is covered with a veil? What air of the court might the seated young woman be singing with a raised right hand marking the tempo? What musical scores are glimpsed among the fallen books at her feet? Why the lute and violin in the foreground? There is only one sure answer, and it is to this last question: Who, finally, is this young man wearing a plumed biretta—very old-fashioned in 1626—playing the harp? Rembrandt. Rembrandt himself.

Does this painting on an oak panel that looks like a genre scene depict a concert, or is it allegorical? Both have been proposed. If we agree that this is an allegory, which may be doubtful, the painting remains indecipherable. How can one not be convinced that Rembrandt at age twenty deliberately makes the choice to be enigmatic? No doubt he senses that it is not up to painting to give mundane answers.

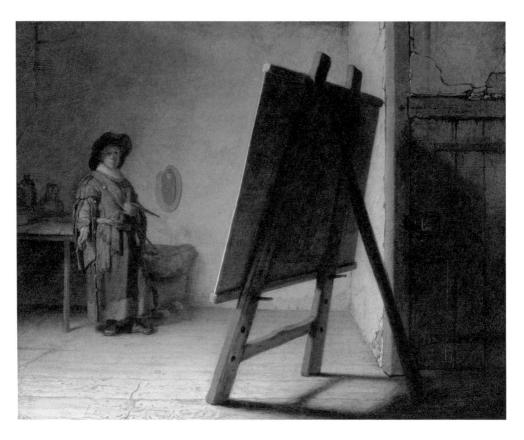

*The Artist in His Studio.* c. 1627–1628. Oil on wood, 24.8 × 31.7 cm. Museum of Fine Arts, Boston. The Zoë Oliver Sherman Collection, given in memory of Lillie Oliver Poor.

# 6. EASEL

In his memoirs, Constantijn Huygens recounts his visit in 1630 to the Leiden studio where Jan Lievens and Rembrandt, both of whom were pupils of Pieter Lastman in Amsterdam, were working at the time: "I feel it my duty to declare that I have never seen so much passion and hard work in any person, at any age and in any profession whatsoever. In truth, these young people do not want to lose one instant. This is the only consideration that matters to them. Surprisingly, they regard the most innocent, youthful entertainment as a waste of time, and behave in this respect as if they were old men who have long since passed the age of these follies." Clearly the condition of the premises was not important to either one of them (opposite). It didn't matter if the plaster above the door was cracking or that, behind the beam on which the door closes, the plaster had fallen and the bricks above the doorframe were exposed. It didn't matter if the easel on which a large panel has been laid had been used for a long time by other painters. The lower cross brace between the supports was hollowed out. In these studios where the artists usually worked seated, other painters likely rested their shoes on it and had worn it down.

This space was not a reception room. Palettes are hanging on the wall, clean, suspended from a nail above the stone on which the pigments are ground. Behind Rembrandt, a table and jugs. Rembrandt, dressed in a kind of greatcoat, has in his hands what it takes to continue working: a brush in the right hand; a palette, a bunch of brushes, and a palm rest in the left hand.

At what stage is the work on this large panel that he looks at from afar? Is the composition laid out? Is he considering the final touches that will be needed to bring a face to life?

Rembrandt is perhaps verifying the pertinence of Horace's remark in his *Ars Poetica*, whose first three words, *Ut pictura, poesis*, have been repeated for centuries:

> *Ut pictura, poesis erit quae, si proprius stes,*
> *Te capiat magis, et quaedam, si longius abstes;*
> *Haec amat obscurum, volet haec sub luce videri. . . .*

In other words: "As is painting, so is poetry; some pieces will strike you more if you stand near, and some, if you are at a greater distance: One loves the dark; another chooses to be seen in the light. . . ." And perhaps he meditates on this statement: "As is painting, so is poetry," which means that a painting, like poetry, is and can only be untranslatable.

# 7. IS THAT IT, OR IS IT THE OPPOSITE?

Rembrandt, a name accompanied by an implacable parenthesis of dates (1606–1669), a span that confines him in the seventeenth century and reminds us that he could only draw upon what that century was in the Dutch United Provinces for his art. The dates are a truism, an obvious fact, and a banality that do not explain why he lives on, why he is, three hundred and fifty years after his death, an essential contemporary.

I think of this remark by Jean Genet, in "Le secret de Rembrandt": "This ethic is not just a vain attempt to spruce up his soul; his work requires it, or rather brings it about. We know this because for perhaps the first time in the history of art, a painter posing before a mirror with an almost narcissistic self-satisfaction, has left us, parallel to his other work, a series of self-portraits in which we can trace the evolution of his method and the action of this evolution upon the man. Is that it, or is it the opposite?"

We have not finished asking ourselves: "Is that it, or is it the opposite?" The portraits Rembrandt paints of himself do not have to assert anything. They lead to meditation, which faces an impenetrable, indecipherable silence.

How can we ignore Goethe's remark: "Art is a mediator of the unspeakable; so wanting to be its mediator in turn through words seems a foolish endeavor"?

Confession: The following pages are a foolish enterprise. We will return, again and again, at the risk of tedium, to what little we can know for certain. But perhaps, with the right questions, we can go further.

*Self-Portrait with Gold Chain*. 1633. Oil on wood,
60 × 47 cm (oval). Signature and date: *Rembrandt
f 1633*. Louvre, Paris.

*Self-Portrait Wearing a Toque and a Gold Chain*. 1633.
Oil on wood, 70 × 53 cm (oval) (RRP, 70.4 × 54 cm).
Signature and date: *Rembrandt f 1633*. Louvre, Paris.

*Self-Portrait with Shaded Eyes*. (1634). Oil on wood, (RRP, 70.8 x 55.2 cm). The Wynn Collection, Las Vegas.

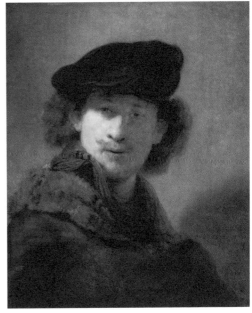

*Self-Portrait with Velvet Beret*. 1634. Oil on wood, 58.3 × 47.5 cm. Signature and date: *Rembrandt f 1634*. Gemäldegalerie, Berlin.

# 8. PEN AND WASH

Drawings. Pen and wash. At twenty or twenty-one years old, Rembrandt, for the first time (providing that earlier sketches have not been lost), draws his features (opposite). Alone. Tousled locks of curly hair, dots for a short mustache above the lip. He does not make these sketches so that one day or another he can take his place in the history of painting. What are they for? To check that capturing a resemblance cannot elude him? Perhaps. He knows that a painter who wants to earn a decent living must paint portraits again and again. It is impossible to escape this obligation.

Would the half-open mouth suggest that he thinks of a common convention repeated for centuries and still being used at the time—that a portrait is most convincing when the model seems just about to say something (opposite, right)? The Netherlandish painter Anthonis Mor van Dashorst, known in Florence as Antonio Moro, in a self-portrait signed and dated *Ant. Morus. Philippi. Hisp. Reg. Pictor sua ipse depictis manu 1558* affirmed this cliché. Moro poses himself before a panel or blank canvas to which is affixed a single sheet of paper, bearing a poem handwritten in Greek:

> Oh! wonder! Whose portrait can this be?
> Without doubt the best of painters,
> an Apelles or Zeuxis. But no
> he must be someone who surpasses both these ancients
> and the moderns too.
> He painted himself after observing
> himself in a mirror. Oh excellent painter!
> This pseudo Mor here, Moro, maybe
> he is about to speak.

At age twenty or twenty-one, was it Rembrandt's ambition to be compared to Apelles or Zeuxis, or to be the one of whom it could be said, "someone who surpasses both these ancients and the moderns too?"

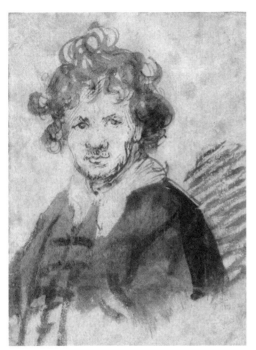 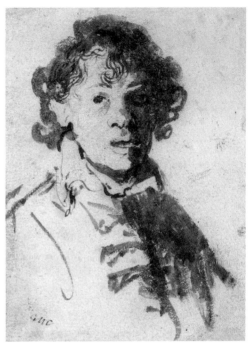

*Self-Portrait*. c. 1628–1629. Pen and brown ink with gray wash, framing line in brown ink, 12.7 × 9.4 cm. Rijksmuseum, Amsterdam.

*Self-Portrait*. c. 1629. Pen and wash, 12.5 × 9.5 cm. British Museum, London.

# 9. A SHADOWED GAZE

1629. At twenty-three, Rembrandt had to demonstrate his mastery, the dexterity with which he wielded a brush. Arnout van Buchell, who came from Utrecht, passed through Leiden in 1628 and met the painter there. He noted that Rembrandt "enjoyed a singular but premature esteem." Premature? Perhaps. If Arnout van Buchell thinks so. But not undeserved. To show, as he must, that he is a virtuoso, Rembrandt paints constantly. And what model is more readily available than himself? He could simply turn to a mirror to face a challenge. In time he will learn to etch the wrinkles on a more mature face, capture the lines carved in the forehead of an old person, like those of his mother, but first he would show that he was able to paint skin unscathed by time.

Rembrandt in front of the mirror. On the lookout, at a standstill. Docile and available model that he is, he begins to unravel what his eyes pursue. His smooth forehead. The lobe of his ear, like a bud. His clean-shaven cheeks. His upper lip and his chin barely shaded by a mustache. And above all else his expression. Worried? Serious? Almost alarmed? (See opposite.)

In *Het Schilder-boeck*, his history of painting published in Haarlem at the end of 1604, Carel van Mander asserted that the eyes are the "windows of the soul." How can one doubt, then, that the painter's eyes, should be brought into the light? Yet Rembrandt chose to paint them in the shadow of his tousled hair, strands falling over his forehead. A paradox.

Perhaps he knew the painting of Adam Elsheimer (1578–1610), who had discovered in Rome, where he died, the piercing light of Caravaggio, a light that he took for himself, as did Nicolaes Moeyaert (ca. 1592–1655), Jan Symonsz. Pynas (ca. 1582–1631), his brother, Jacob (ca. 1592–1650), and Pieter Lastman, from whom Rembrandt came to learn his trade at the end of 1624. Since Lastman was recognized for distributing this light and its shadows in his works, he was adulated, celebrated in Europe, and even invited to paint the chapel of Frederiksborg Castle, residence of the king of Denmark. It would be absurd for Rembrandt to deprive himself of this *argument*; it would be absurd not to prove that, even if he had never set foot in Rome, he knew something about the painting of this Michelangelo Merisi da Caravaggio, who had just turned the world of painting upside down.

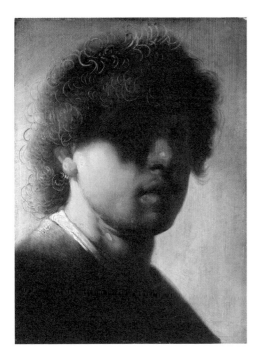

*Self-Portrait*. 1629. Oil on wood, 23.4 × 17.2 cm.
Gemäldegalerie Alte Meister, Kassel.

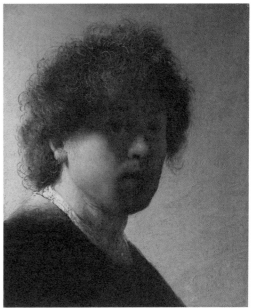

*Self-Portrait*. c. 1628–1629. Oil on wood, 22.6 × 18.7 cm (RRP,
22.5 × 18.6 cm). Rijksmuseum, Amsterdam.

# 10. CHIAROSCURO

The differences and contrasts of light and shadows: the brightness here, the darkness there, what is called chiaroscuro, led some to say without the slightest hesitation that Rembrandt was to be counted among the Caravaggesques.

Joachim von Sandrart, in his book *Teutsche Academie der Edlen Bau- Bild- und Mahlerey-Kunste*, a series of short biographies of artists, published in 1675, said of Rembrandt: "There is little light in his works, except where he wanted to focus interest; elsewhere he merged light and shadows with great mastery, with a well-measured reflection, and created passages from light to darkness with great skill." This well-known trope enables Francesco Algarotti to assert in 1762 in his *Saggio sopra the pittura* that Michelangelo Merisi da Caravaggio was "il Rembrante dell'Italia," the Rembrandt of Italy. Twenty years later, Luigi Lanzi puts things in place with this definition of Rembrandt: "*detto da alcuni il Caravaggio degli Oltremontani*" ("called by some the Caravaggio from the other side of the mountains").

Case closed. The same chiaroscuro for Caravaggio and Rembrandt.

Which, insidiously, suggests that Rembrandt shamelessly plagiarized Caravaggio. The chronology can only confirm it. Rembrandt was born in 1606, Caravaggio in 1571. And when Caravaggio died in 1610 on a beach in Porto Ercole, Rembrandt was just a four-year-old child in Leiden.

Conclusion: Rembrandt has taken up the very intense chiaroscuro conceived by Caravaggio.

And yet, Rembrandt never saw a work by Caravaggio.

Did he ever see copies or paintings "in the style of" made by Hendrick ter Brugghen (1588–1629), Gerrit van Honthorst (1590–1656), nicknamed Gherardo della Notti, or Dirck van Baburen (1594 or 1595–1624)? In Utrecht, back from Italy, where they had spent several years (six or seven for ter Brugghen and van Honthorst and ten for the latter two), these artists were haunted by the works of Caravaggio, as well as those of Annibale Carracci, Guido Reni, Domenico Zampieri, and Orazio Gentileschi. Did Dirck van Baburen's etching (attributed by some to Michael Sweerts) in the style of Caravaggio's *Entombment of Christ,* painted for the chapel of the Vittrice family in the Chiesa Nuova of Rome, ever pass through the hands of Rembrandt?

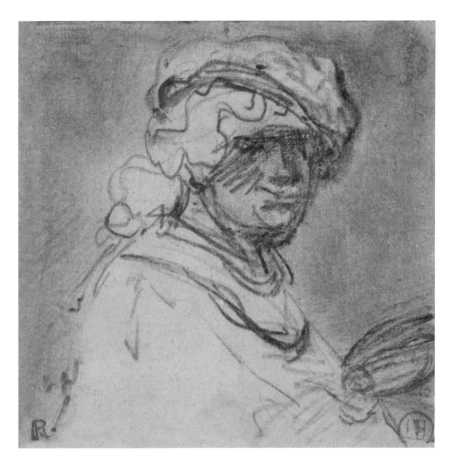

*Self-Portrait.* (1633). Black chalk, 11.3 × 11.3 cm.
Musée des Beaux-Arts, Marseille.

Jacob van Swanenburgh, with whom Rembrandt studied in Leiden, lived in Rome and Naples, and he could have even crossed paths with Caravaggio. He undoubtedly knew the Italian's work. Did van Swanenburgh talk about him to his student; did he mention the singularity of his painting? The Flemish painter Louis Finson (ca. 1580–1617) took the style of Caravaggio for his own. He copied the master's works. Some of his copies passed into the hands of Pieter Lastman, who was Rembrandt's teacher in Amsterdam. Among them was *Mary Magdelen in Ecstasy,* painted in Naples in 1606. This copy was in turn copied by Wybrand de Geest (1592–1661). De Geest, from Friesland, was a distant relative of Saskia, Rembrandt's wife. This cannot be taken as proof that Rembrandt, her husband, was able to see this copy of a copy.

Though Rembrandt may have read the book *Het leven der moderne oft deestijtsche doorluchtige Italiaensche schilders* (1603), on modern Italian painters, he would not have taken long to find out that the author, van Mander, could not have seen a single work of Caravaggio. Not one. How can we trust what he writes when he reports that, according to Caravaggio, all works "are only trinkets, children's games, or trifles, if they are not made or painted according to reality and that there is no better way than to follow nature"? Still, we must respect Arnold Houbraken's report that Rembrandt "had made the observation of nature his basic rule, considering the rest with suspicion," and it is obvious that he acknowledged the words spoken by Caravaggio in his practice.

All the painters who passed through Rome and Naples and saw Caravaggio's paintings made work that bears traces of his incomparable chiaroscuro. Caravaggio owed his unquestionable glory throughout Europe to this technique. It is this glory that Rembrandt seemed to want to measure himself against. From the first self-portrait he painted, the veil of shadow with which he covered his face was a sign of the way he intended to take up the challenge.

Chiaroscuro and observation of nature are not the only things to justify the comparison of Caravaggio and Rembrandt.

In a paper entitled "Considerazioni sulla pittura," an amateur artist from Rome, Giulio Mancini, wrote in the early seventeenth century that Rembrandt "owes a lot to Michelangelo da Caravaggio for the use of the colors he pioneered and which we now like to copy." He was relentless in discrediting Rembrandt, even though he admits that Rembrandt was able to attain "so high a level in art, thanks to a great zeal for work, but

also to a propensity and an innate inclination." He just had to write: "By his art of color, he has joined those who are much more dyers than painters, since they juxtapose raw and stark colors without restraint or sensitivity, so that their works have nothing to do with nature and only look like boxes of all the colors found in a haberdashery, or the linen that one brings back from the dyer's shop."

This "dyer" Rembrandt, as a sinner at the foot of the Cross, wears a blue doublet (page 77). His choices of hue—like the red sleeve of the prodigal son in the tavern who raises his glass for a toast, like the bright plumage of the bittern he brandishes in *Self-Portrait with a Dead Bittern*, etc.—are all signs of the place that Rembrandt gives to color (pages 86 and 106).

Like Caravaggio, whose painting he has never seen.

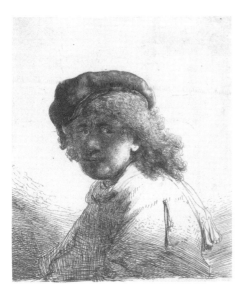

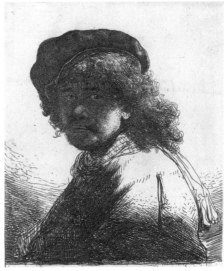

*Self-Portrait in Cap and Scarf*. 1633. B17. Etching, 1st state, 14.6 × 11.8 cm. Rijksmuseum, Amsterdam.

*Self-Portrait in Cap and Scarf*. 1633. B17. Etching, 2nd state, 13.3 × 10.4 cm. Signature and date: *Rembrandt 1633*. Rijksmuseum, Amsterdam.

# 11. TRONIES

Rembrandt with curly hair, Rembrandt bent over, Rembrandt grumpy, with eyebrows drawn together, Rembrandt shouting, Rembrandt frantic or frightened, Rembrandt with his tousled mop of hair, Rembrandt impassive or perhaps indifferent, Rembrandt wearing a cap whose brim bathes the top of his face in shadow, Rembrandt in a fit of laughter, Rembrandt surly, Rembrandt scowling if not snarling, Rembrandt dismissive, Rembrandt gruff, Rembrandt worried . . .

In Leiden, between 1628 and 1631, in his studio at Weddesteeg where, most likely, day after day, he convinced himself he must give up leaving for Italy as his teacher Lastman had been able to do, Rembrandt endlessly used himself as a model for *tronies*, as works showing exaggerated expressions that revealed emotions—from astonishment to anger, from devotion to tenderness—were called. To be the history painter that he had the ambition to become, he must be able to depict all the feelings. Which model could be more available than himself? None. Which model could he ask to mimic the needed expressions, grimace after grimace? None. What's more, since he is still unknown, he hasn't a guilder to give to anyone to pose for him. And perhaps he has only very small copperplates, due to this same concern for money. The largest ones he uses to engrave his features rarely measure more than four inches.

Obviously, to sketch expressive faces, it might be enough to take a sheet of paper and just draw. Charcoal, black stone, or ink and wash would do the trick. Rembrandt chose etching. Why impose this constraint on himself? Could it be because in Leiden he had to rise to the challenge made from beyond the grave by Lucas van Leyden (ca. 1494–1533), whose prints were praised throughout Europe? Could these copperplates be a sign of his ambition?

Every time, for each one of these portraits he poses for in front of a mirror, he must go through the same ritual. Sand and polish the copper, clean and degrease it. Put it on the ground, spread it with a pad to make sure that the layer is regular and thin. With the etching needle in hand, draw, scratch the ground, cut into it, and scrape it off. Make a fast sketch, lines and hatching. Some crisscross, others parallel. Then cover the etched plate with a bath of dilute acid. The exposed parts are no longer protected by the ground. The

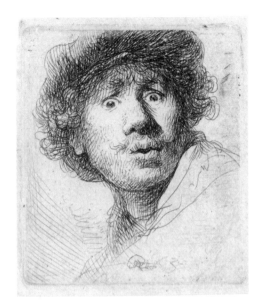

*Self-Portrait*. 1630. B320. Etching, 1st state, 5 × 4.5 cm. Signature and date: *RHL 1630*. Rijksmuseum, Amsterdam.

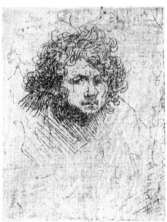

*Self-Portrait Leaning Forward*. (1628). B5. Etching, 1st state, 6.4 × 5 cm. Rijksmuseum, Amsterdam.

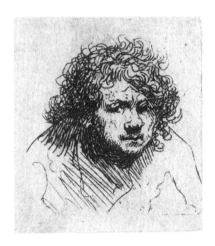

*Self-Portrait Leaning Forward*. (1628). B5. Etching, 3rd state, 4.3 × 4 cm. Rijksmuseum, Amsterdam.

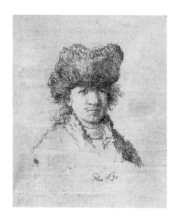

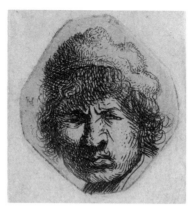

*Self-Portrait in a Fur Cap.* 1630. B24.
Etching, 9.2 × 6.8 cm. Signature
and date: *RL 1630*. Rijksmuseum,
Amsterdam.

*Octagonal Self-Portrait.* (1630). B336.
Etching, 1st state, 3.9 × 3.6 cm. Rijksmuseum,
Amsterdam.

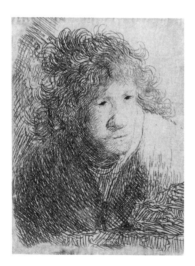

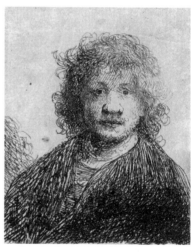

*Self-Portrait (Black Eyes).* (1626–1630).
B9. Etching, 1st state, 6.5 × 5.2 cm.
Rijksmuseum, Amsterdam.

*Self-Portrait with a Broad Nose.* (1626–1630).
B4. Etching, 1st state, 7.1 × 5.9 cm.
Rijksmuseum, Amsterdam.

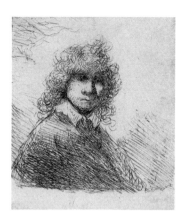

*Self-Portrait Bareheaded, with Curly Hair.* (1628). B27. Etching, 1st state, 9 × 7.2 cm. British Museum, London.

*Self-Portrait (Oval).* (1630). B12. 1st state, 9 × 5.3 cm. Rijksmuseum, Amsterdam.

*Self-Portrait with Cap Pulled Forward.* (1630). B319. 1st state, 5.6 × 4.5 cm. British Museum, London.

*Self-Portrait with Long Bushy Hair*. (1631). B8. Etching, 1st state, 9 × 7.6 cm. Rijksmuseum, Amsterdam.

*Self-Portrait in a Cloak with a Falling Collar.* 1631. Etching with drypoint and burin, 6.5 x 5.5 cm. British Museum, London.

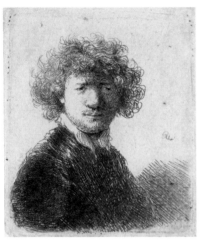

*Self-Portrait Bareheaded, with Curly Hair.*
(1628–1630). B27. Etching, 2nd state,
5.6 × 4.9 cm. Rijksmuseum, Amsterdam.

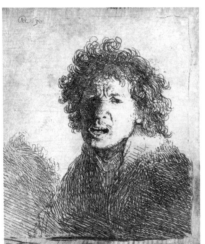

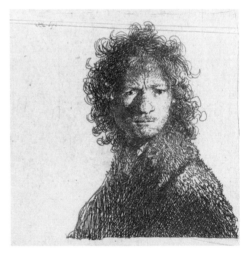

*Self-Portrait, Open-Mouthed.* 1631. B13.
Etching, 1st state, 8.3 × 7.2 cm. Signature and
date: *RHL 1631*. Rijksmuseum, Amsterdam.

*Self-Portrait, Frowning.* 1630. B10. 1st state,
7.5 × 7.5 cm. Signature and date: *RHL 1630*,
Rijksmuseum, Amsterdam.

acid bites into the copper, leaving grooves, etching the lines made by the needle into the metal. The way in which the plate is bitten into needs to be watched over, because the depth of the grooves will determine the density of the black lines in the print. Some lines have to be protected, while the acid is allowed to bite more deeply into others. Next, the copperplate is washed, the ground removed. After inking the plate with an ink pad, it has to be wiped with a piece of tarlatan cloth. To make sure that it is perfectly inked and that no stain alters it, the printer sweeps the surface with his hand. Then a sheet of paper is chosen, dampened to make it more porous so it soaks up the ink better. The copperplate is put on the press. A kind of cloth jacket is put around the plate to protect the edges of the sheet as it goes through the press.

Now one must watch the presswork and look at the first proof. And, if this one is disappointing, rework the plate, with the burnisher that flattens unwanted cuts, with a burin, with a drypoint that will lift burrs that retain the ink. Maybe even use the burr-cutter here and there. And then make a new print.

Did Constantijn Huygens, who passed through Leiden and discovered Rembrandt there, see these first etchings? He writes that he saw *Judas Repentant, Returning the Thirty Pieces of Silver* painted in 1629: "I maintain that Protogenes, Apelles, or Parrhasius would never have imagined (and if they returned to Earth, they would be equally incapable of it) that a young boy, a beardless miller, could put so much feeling into a character and give such a complete depiction. At the very moment when I write these words, I am still overcome with admiration. Honor to you, Rembrandt!" Would this painting have elicited such admiration, such praise, if Rembrandt had not for months been tirelessly practicing all these expressions to engrave his *tronies*?

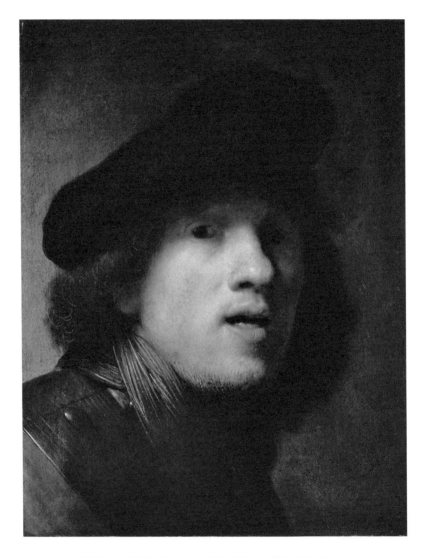

*Self-Portrait.* (1628). Oil on wood, 44.5 × 34.3 cm (RRP, 42.8 × 33 cm).
Indianapolis Museum of Art. The Clowes Fund Collection.

# 12. HERE AND NOW

In July 1545, Pietro Aretino wrote this warning to Leone Leoni, a sculptor known for his portrait medals of prominent people: "Do not make portraits of those who hardly know themselves and that nobody else knows." If Rembrandt, as a young man in Leiden, is just beginning to be known, and if later in Amsterdam he is recognized and still famous even though he has gone bankrupt, we must ask an impudent question: Has he ever known himself? Could his self-portraits be the sign that he struggled to answer the injunction "Know thyself"? Could it be that he resigned himself, with the offhandedness of which pride is capable, to not ever knowing what he might have been and to always be unaware of everything he was—perhaps—able to be? As to what he was, here and now, between oblivion and uncertainty, what more pertinent and more intense answer could he give than a portrait of himself?

# 13. STUDIO

A drawing (opposite). Rembrandt at work. Resting his body against the back of the chair he was sitting on a moment ago, he leans toward the panel on the easel, palm rest and brushes in his hand. He searches, watches closely, scrutinizes. What rework is he considering? What shadow still needs to be toned down? Should he rearrange the composition? Is Rembrandt anxious? Worried? The panel with the rounded upper edge is similar to the one on which he painted *Christ on the Cross* in 1631 and also corresponds to the format of a series of paintings (1633–1646) depicting the scenes from the Passion that will become part of the collection of the stadtholder, Frederick Henry, Prince of Orange-Nassau. This body of work should allow Rembrandt to prove that he, of the Reformed United Provinces, is able to stand up to the painter of the very Catholic Spanish Netherlands, Peter Paul Rubens. So it is no coincidence that the Christ painted in 1631, Christ whose right side was not yet pierced, this Christ who exclaims, *"Eli, Eli, lama sabachthani!"* ("My God, my God, why hast thou forsaken me?"), may pass for a variation of the one Rubens painted nearly twenty years earlier. Paulus Pontius had just presented an etched copy of it to Amsterdam.

The attention with which Rembrandt inspects his painting does not allow the slightest distraction. A few years after the death of Rembrandt, Filippo Baldinucci reports: "When he was working, he would not have granted an audience to the first monarch of the world, who would have had no choice but to go away again and again until he finally found Rembrandt freed from his work." This intensity that does not admit any type of disturbance is witnessed in this drawing.

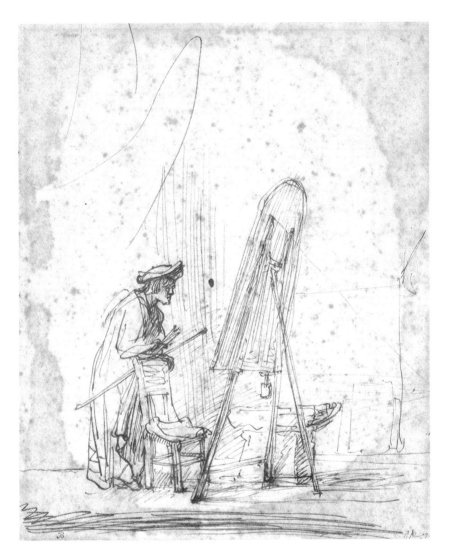

*The Artist in His Studio*. (1632). Pen and bister (brown ink),
20.5 × 17 cm. Private collection.

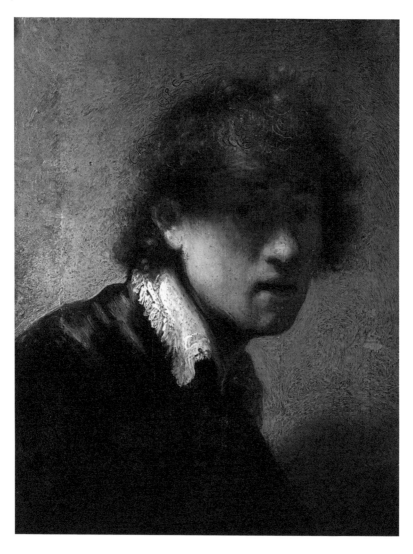

*Self-Portrait*. 1629. Oil on wood, 15.5 × 12.7 cm. Signature and date: *RHL 1629*. Alte Pinakothek, Munich.

# 14. A MATTER OF MATERIALS

The background is a gray color wash that barely covers the wood (opposite). Here and there the paste is thicker, marked by the strokes of a hard brush. The locks of hair that frame Rembrandt's head and forehead are not painted. As was his practice, rather than painting them, he used an etching needle—or the handle of a brush, perhaps—and scratched the paint, uncovering the wood beneath. Small traces of a pasty white suffice to show the fringes of the shirt collar. These variations of the process—to build up here, to scratch there—are as important as the shadows and the light. All means are permitted to assert that a painting, even a portrait, beyond the necessary resemblance, is also (first of all?) a matter of materials. At twenty-three, did Rembrandt want to assert (already), as no one else had, the place that must be given to the material itself, the paint?

# 15. THE FACE IN THE MIRROR

Emil Cioran's aphorism easily comes to mind: "Criticism is a misconception: We must read not to understand others but to understand ourselves." Apply this aphorism to these self-portraits: You must look at them not to understand Rembrandt, but to understand yourself. Another thought of Cioran's in *Anathemas and Admirations* (1987): "Not knowing oneself is the universal law, and no one transgresses it with impunity." That transgression was the risk Rembrandt took—posing for more than forty years before a mirror—from 1625, the year when he painted himself among those at *The Stoning of Saint Stephen* (page 10), to 1669 (page 152), when his chin is heavy, his face swollen by the decay of time, which chewed, crumpled, scuffed, and creased his skin. This confrontation was clearly an exercise and a discipline as well as an asceticism and a quest.

If, for four years already, Rembrandt has been painting, drawing, and etching his features, a print of 1629 shows the tumult involved in this face-to-face with the mirror (page 45). Like no other object, the mirror is weighted with myths and mysteries. It is a doorway between the material world and another, spiritual one; a metaphor for the cloth

and veil that were applied to the face of Christ—the Mandylion and Veil of Veronica—as it is a metaphor for the pool of water over which Narcissus leaned. How could Rembrandt not have known what Alberti asserted in 1435: "I used to tell my friends that the inventor of painting, according to poets, was Narcissus, who was turned into a flower; for, as painting is the flower of all arts, so the tale of Narcissus fits our purpose perfectly. What is painting but the act of embracing by means of art the surface of a pool?"

Beyond being a magical portal for a painter, a mirror is also a necessary intermediary for knowledge of the self. According to Seneca: "The mirror was invented so that man could know himself. It was very beneficial for him. First of all, it provides the knowledge of his person. In addition, in some cases, wise counsel: Handsome, he will avoid what would degrade him; ugly, he knows that he must have moral qualities to compensate for defects of the body; when young, the blossoming of age warns him that it is for him the time to learn and to dare valiant deeds; an old man, he will give up what would dishonor his white hair, and sometimes turn his thoughts towards death. That's why nature has given us the opportunity to see ourselves." Diogène Laërce reports that Socrates advised young men to look at themselves often in a mirror: "'If you are handsome,' he said, 'remain worthy of your beauty; if you are ugly, let your knowledge make your ugliness forgotten.'" And Apuleius again recalls: "Is not Socrates the philosopher who enlisted his disciples to look at themselves frequently in a mirror? Those who took pleasure in their beauty, to watch attentively not to dishonor the nobility of their features by bad behavior; those who considered themselves not endowed with external attractiveness, to apply themselves with care to have their moral qualities make their ugliness forgotten. It is thus that the wisest of all men used a mirror even to form good morals." Perhaps the conscience of the painter counts on Saint Augustine: "Now it is certain that which the eyes behold is not pronounced false unless it possess some likeness to the true." And: "We call . . . the face reflected from a mirror a false face." Saint Augustine asks this question: "For does not your image in the mirror seem to be you as if it willed you to be your very self, but to be false for the reason that it is not?"

You have to paint to avert the falsity of the image "in the mirror."

That Rembrandt may have had nothing to do with what Alberti, Seneca, Socrates, Saint Augustine, and others have written about the mirror is of no importance. Some of the art collectors who bought his self-portraits did not fail to think about it.

And he himself would have soon become aware of the questionable nature of his project, if only thanks to an observation: When he looks in the mirror and draws his own features on the copperplate, he knows that in the reflection, though right-handed, he appears left-handed. But when he examines the proof he pulls from the plate, he can see that the lines drawn on the left side of the copper are reproduced on the right, rendering him right-handed. So, too, his monogram and the date, 1629, written from left to right on the copper, appear reversed from right to left at the top of the sheet. (Perverse comment: Watching his face *put right* by the etching does not change the fact that it was *switched around* by the mirror.)

The consequence of these transmutations is not insignificant: Looking at a self-portrait is looking in a mirror.

*Self-Portrait, Bare-Headed*. 1629. B338. Etching, 1st state,
17.4 × 15.4 cm. Signature and date: *RHL 1629* (in reverse).
Rijksmuseum, Amsterdam.

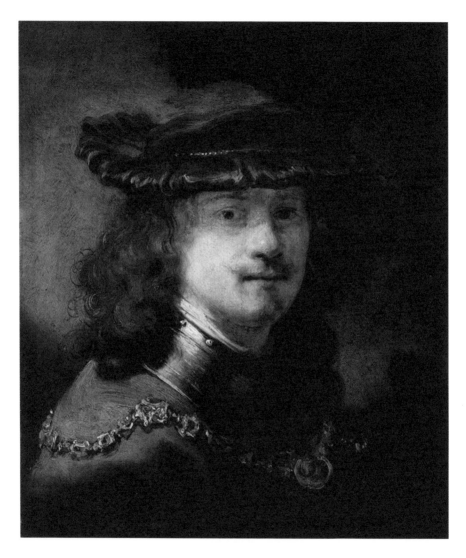

*Self-Portrait with a Velvet Beret and Gold Chain*. (1634). Oil on wood,
55 × 46 cm (RRP, 56 × 47 cm). Gemäldegalerie, Berlin.

# 16. THE PARABLE OF THE TALENTS

All citizens of the Republic of the United Provinces had to read the parable of the talents from the Gospel According to Matthew (25:14–30). The evangelist tells the story of a "man going on a journey, who called his servants and entrusted to them his property. To one he gave five talents, to another two, to another one, to each according to his ability. Then he went away. He who had received the five talents went at once and traded with them, and he made five talents more. So also he who had the two talents made two talents more. But he who had received the one talent went and dug in the ground and hid his master's money." On the master's return, the "wicked and slothful servant" who has hidden his talent in the earth is rebuked. And this "worthless servant" is chased out "into the outer darkness," even though the same evangelist quotes these words of Christ (Matthew 19:24): "And again I say unto you, it is easier for a camel to go through the eye of a needle, than for a rich man to enter into the kingdom of God." It is obvious that we must be like those two servants who knew how to render ten and four talents to their lord. The timid mediocrity of the third is not acceptable. This certainty is that of the regents, patricians, and potentates enriched by the United East India Company, even if it means having to order from a painter one of those still lifes that meditates on the words of Ecclesiastes (12:8–10): "Vanity of vanities, saith the preacher; all is vanity."

The parable of the talents concerns everyone in the same way. Rembrandt cannot, must not, ignore its imperative. The "beardless miller"—as Constantijn Huygens referred to him—is eager to prove himself to Amsterdam. The Gospel According to Matthew provides the moral foundation of his ambition.

Painting is his way to advance himself—painting that meets the demands of his patrons. They want their importance recognized. The paintings made for these men and women, for Jan Krul; Willem Burggraeff and Maertgen van Bilderbeecq, his wife; for Johannes Elison and Maria Bockenolle; for Maerten Soolmans and his wife, Oopjen Coppit; and for so many others, would only be worth to him the fame to which he aspired. Which is to say that then, during the 1630s, painting was the *means* to prove his worth. Humbly, it must fulfill the expectations of these worthy individuals. But humility was not Rembrandt's forte. Already his etchings suggest that his ambition aspires to fame, and why not to glory like that of Lucas van Leyden or Peter Paul Rubens?

# 17. GORGET

As far as I know, the *Description de l'île de portraiture et de la ville des portraits* that Charles Sorel published in 1659 was not then or ever translated in the Netherlands. No matter. Sorel lists the streets of this island: the street of heroic painters; of amorous, burlesque and comic, or satirical painters; the street of the critical painters or indifferent painters; and others as well. He affirms without the slightest hesitation that those commissioning a portrait all inevitably want it to show "what they appeared to be, not what they actually [are]." A few decades later, Rétif de la Bretonne pointedly commented: "Without being aware of it, one gets accustomed to find in the original sitter the charms of a flattering portrait." Rembrandt already knew these things.

Above all, Rembrandt knows he must be noticed. He has to seduce (or lure, or convince, which amounts to the same thing) his public, his patrons. To be noticed requires the use of adornments. He does not forgo any of them. First there is the iron gorget. On eight occasions, when he was in Leiden in 1628 and 1629, and after he moved to Amsterdam—in 1634, 1635, 1636, and again in 1637—he wears this piece of armor for a self-portrait.

In 1629, the war that had already lasted sixty years was far from over. In April, Frederick Henry, Prince of Orange, besieged the Habsburg city of 's-Hertogenbosch in the name of the Republic of the Netherlands with twenty-eight thousand men; the city surrendered in September. Meanwhile, in August, the sovereignty of the Protestant Republic was threatened by the capture of Amersfoort, only sixty miles from Amsterdam, by Habsburg armies. Of course, at twenty-three, Rembrandt would want to wear his gorget, which protects the upper back, chest, shoulders—and, badly, the neck—of militia soldiers (opposite). Announcing "I am the same as you; I am your neighbor"—with one difference. There is no question of enlisting. But not enlisting does not forbid playing a role.

To paint himself as the soldier he is not is to paint a lure.

To paint himself as the solder he is not is to hold the attention, let us say, of an officer who will recognize that the painter to whom he speaks knows (if only more or less) the rigors of military life.

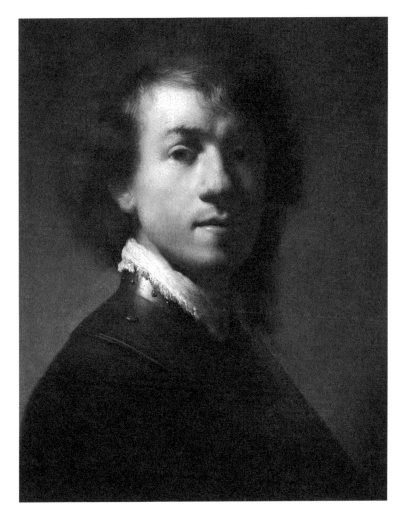

*Self-Portrait with a Gorget.* (1629). Oil on wood, 37.9 × 28.9 cm. Mauritshuis, The Hague. According to the RRP, this self-portrait may have undergone interventions by another hand in the studio or, worse yet, may be a copy of the original preserved at the Germanisches Nationalmuseum in Nuremberg. It is open to doubt, unless the student who intervened in the studio or the copyist possessed the genius of the master.

But does this officer notice the long lock of hair (called a *cadenette* in French and a love-lock in English) falling on Rembrandt's left shoulder? If what is implied by the presence of the gorget is clear, what this love-lock means is less so. The love-lock, which first appeared in the French court, was associated with Frederick V, then living in exile in The Hague. Nicknamed with scorn the Winter King because he reigned only one year over Bohemia, Frederick was a Protestant (and an ally of the Protestant Republic) driven from his throne and Palatinate by the very Catholic allies of the Hapsburgs. The one painted by Rembrandt is less neat than the one, for example, that falls and curls on the shoulder of Simon Vouet in the portrait he painted of himself in 1626 or 1627, but it is, nevertheless, a love-lock. This strange fashion, which Rembrandt no doubt calls a *liefdelok*, got its name from one of the lovers of Louis XIII, King of France and Navarre. Says Gédéon Tallemant des Réaux: "The constable of Luynes, favorite of Louis XIII, had two brothers: one was named Brante, and the other Cadenet. They were all three handsome boys. Cadenet, later Duke of Chaulnes and Marshal of France, had a handsome head and mustache and from him the *cadenette* took its name." The doings of the King of France and Navarre matter not at all to Rembrandt. What is important to him is to show that he is au courant with the court of The Hague.

Would our officer, gazing on Rembrandt's picture, notice the flash of light on the edge of this gorget, the white dots and commas on the rivets? Is he aware that these minute details act as a counterpoint to the brutality of the angry strokes with which the frayed collar of the shirt is painted? They are—he has probably missed them—signs of the mastery this young painter is already demonstrating.

But perhaps Rembrandt is not careful of one thing: The rivet on his right shoulder does not have the slightest notch underneath it. This is enough to suggest that it is not the rivet-pivot, with its notch used to close the gorget, which ought to be on the right shoulder. But not in this painting. Evidence of the mirror?

# 18. LAUGHTER

Charles Blanc, in his book published in 1853, *L'Œuvre de Rembrandt*—exceptional at the time because it was one of the first art books to be illustrated with photographic reproductions—includes a note that ends with these words: "Mystic marriage of art and science, photography applied to Rembrandt's work will be, so to speak, a reprint of his etchings by light, so that this artist, who knew so beautifully how to interpret nature, will now in his turn be interpreted." In his commentary on the first etching reproduced—number 316 in the Bartsch catalogue—he writes: "What if the self-portraits of Rembrandt have only a family resemblance among them? This would have been because, conceivably, the painter was seeking in his mind not the model of a rigorous portrait, but the pattern of a general expression. In other words, Rembrandt pursued the ideal of his thought in the reality of his figure. A remarkable thing, moreover, is that among the immense work of this great man we find only twice the physiognomy of mirth; a single print of him, and a single painting in the Dresden Museum, representing him laughing with open mouth. Rembrandt was a man who was usually serious, melancholy, and dreamy, and one can judge from all his works that the expression of gaiety was, in him, rather the study of one of the aspects of life than the manifestation of his own heart." Objection. The etchings for which Rembrandt acts as a model, playing all the roles and expressing the most diverse feelings, comprised a catalogue that he could consult for his history paintings. These rarely called for laughter.

Blanc has certainly forgotten what Samuel van Hoogstraten wrote. A pupil of Rembrandt in the 1640s, van Hoogstraten published in 1678 a singular treatise on painting, *Inleyding tot de hooge schoole der schilderkonst*, in which he noted: "If one wishes to excel in this most noble part of art (the passions), one must be sure to become an actor." What does it matter that Rembrandt never read Shakespeare or attended a performance of *As You Like It*? In Leiden, and later in Amsterdam, these words of Jacques, in Scene VII of the second act, speak of what Rembrandt knew:

All the world's a stage,
And all the men and women merely players;
They have their exits and their entrances,
And in his life a man plays many parts. . . .

Between the laughter of the actor and the laughter of the man, let's adopt the point of view of Jean Genet: "In his last self-portraits, we no longer find any psychological indications whatsoever. If we really wanted to, we could see something like a look of goodness. Or an air of detachment? Whatever, here it's all the same."

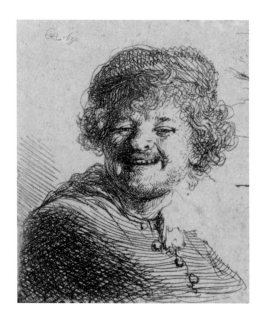

*Self-Portrait in a Cap Laughing*. 1630. B316. Etching,
5.2 × 4.3 cm. Signature and date: *RHL 1630*.
Rijksmuseum, Amsterdam.

# 19. GOLD CHAINS

In 1629, for the first time, Rembrandt adorned himself with a gold chain. In the three portraits he painted of himself during the same year, a similar chain drapes his shoulders and his chest. In 1630, it goes around a fur collar. And in 1633, he depicts it three times (pages 6 and 22). Likewise, it appears in an etching of 1634 and in a painted portrait where he was wearing a remarkable beret embellished with a feather (pages 46 and 84). And this chain, often present yet always different, is again around his neck in 1638, 1640, 1642 or 1643, 1645, 1654, 1655, and 1669, finally, for one last time (pages 59, 74, 94, 95, 97, 103, 104, 105, and 130).

It is uncertain whether this chain has a meaning or if it simply provided a pretext to punctuate dark clothes with light. Princes of the day were known to favor artists—Titian, Vasari, Rubens, van Dyck, Hendrik Goltzius, for example—with the gift of a gold chain. Had he known this (who can be certain?), it likely would have weighed less with Rembrandt than testimony from a far older world.

Perhaps Rembrandt is making a subtle allusion to the chain of gold that, according to legend, Alexander the Great gave to his painter, Apelles. Horace assures us: "That same great king forbade by an edict that anyone other than Apelles could paint him." Cicero explains the reason for such a decree, which also reserved the right to sculpt him to Lysippus alone: "He thought that their art would not bring less glory to him than it did to them." Plutarch relates: "Apelles had made a rule not to let a day pass, busy as he was, without having practiced his art by drawing some line." This principle made its way into a proverb: *Nulla dies sine linea* ("Not a day without a line"). A precept that undoubtedly became a rule for Rembrandt.

Apelles was adept at putting in his place anyone who had the impudence to question his painting. Once, reports Pliny, in his *Natural History* (Book XXXV), a shoemaker protested that the painter had "attached one strap less than was needed on the sole of a sandal." After the strap was added and the same shoemaker ventured to make another remark about the leg, Apelles averred that a shoemaker should stick to his sandal.

To those who claimed to be worthier of respect than a shoemaker, Rembrandt might have cited another anecdote: "Alexander, seeing his portrait painted by Apelles at

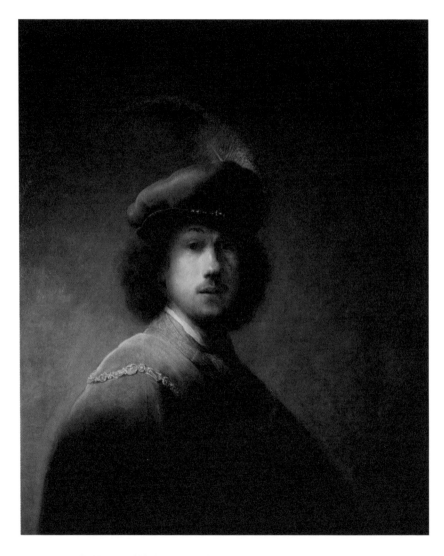

*Self-Portrait*. 1629. Oil on wood, 90 × 73 cm (RRP, 89.5 × 73.5 cm).
Signature and date: *RHL 1629*. Isabella Stewart Gardner Museum, Boston.

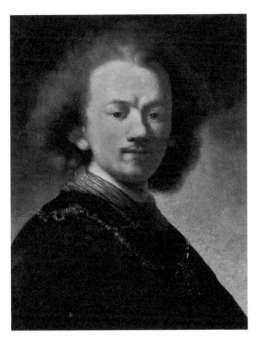 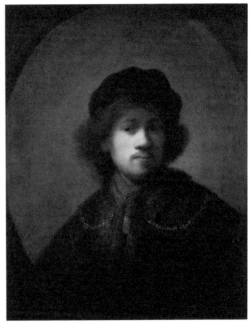

*Self-Portrait*. (1629–1630). (RRP, 61.4 × 46.9 cm). Private collection. Intervention in the studio? Copy of a lost original?

*Self-Portrait*. (1629–1631). Oil on wood, 69.7 × 57 cm (oval). Signature (possibly not original): *Rembrandt f*. Walker Art Gallery, Liverpool. The RRP only recognizes this work as being from the studio.

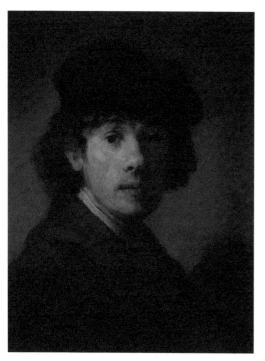

*Self-Portrait*. 1630. Oil on wood, 21.9 × 16.5 cm. Metropolitan Museum of Art, New York. Bequest of Evander B. Schley. In the eyes of Gerson and the RRP this work passes for a copy.

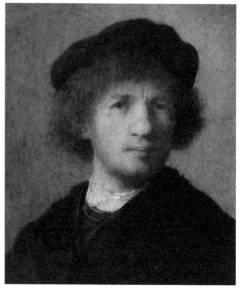

*Self-Portrait*. 1630. Oil on copper, 15 × 12.2 cm. Signature and date: *R... 1630*. Nationalmuseum, Stockholm.

Ephesus, did not praise his painting as it deserved. But his horse, having been put in the presence of the painting, began to neigh in the direction of the horse depicted in the portrait, as if it were also alive: 'Well! King,' said Apelles. 'Your horse seems to like the painting much more than you do.'"

Alexander's horse, Bucephalus, is consecrated by this anecdote as worthy of being considered a connoisseur of art, the first art critic, or perhaps that honor belonged to the birds that, says Pliny, upon seeing "grapes so handsomely depicted" by the painter Zeuxis "fluttered near them." These fables—Apelles's horse, Zeuxis's grapes—became clichés of art studio lore, repeated ad infinitum after their rediscovery in the fifteenth century. The value of painting itself was affirmed, as when Philostratus stated, "Whosoever scorns painting is unjust to the truth; and he is also unjust to all the wisdom that has been bestowed upon poets."

How could Apelles and Zeuxis not be models for Rembrandt? How could he not want to signal this, to those who might commission their portrait, with a chain similar to the one received by Apelles, who, says Pliny, when painting Alexander's mistress, Pancaste, also "painted himself in this portrait"?

# 20. CREDO

In 1630, Rembrandt painted himself three times. Twice on wood. Once on a copperplate. He only signed and dated *RL 1630* on the largest of the three. This largest oil on wood measures 61.4 × 46.9 cm (page 55, left); the other wooden one, 21.9 × 16.5 cm (opposite, left); and the copperplate, 15 × 12.2 cm (opposite, right). In one, he is bareheaded; in the other two, he wears the same beret. Not the smallest accoutrement. No gorget, no chain, no feather, no love-lock. A dark coat or jacket. The collar of a white shirt. Nothing else. Portraits of a young man who is twenty-three or twenty-four years old. A young man with hair falling on his neck, a painter dressed in the humble clothes he wears day after day in his studio in Leiden.

Could Rembrandt have taken this prayer written by Calvin to heart?

"Lord, who is the source of all wisdom and learning, since it pleases you to give me during my youth the instruction that will be useful for me to live in a holy and honest way, at the same time please enlighten my intelligence so that I understand the teachings that will be given to me. And since you promise to enlighten by your wisdom and knowledge the small and humble ones with a righteous heart, I ask you, O my God, to create in me that true humility which will make me docile and obedient to you first of all, but also to those whom you have established to instruct me."

Unverifiable hypothesis.

Certainly, it was not his Catholic mother who introduced him to this pastor. The Calvinism of his father was not the most rigorous. What was Rembrandt's faith? During his life, what certitudes did he possess? He only depicted himself once as a Christian, in 1638, wearing on his chest a cross hanging on a chain (opposite). What beliefs did he share with the Mennonites, Remonstrants, Catholics, Counter-Remonstrants, and the Jews who were his friends, his models, his clients? Bernhard Keil, who was a student of Rembrandt's for eight years, suggests that his teacher was a Mennonite, a follower of Menno Simons, a priest who underwent a conversion to Protestantism in 1536. Simons had been a Frisian, as was Jan Cornelisz Sylvius, preacher of the Oude Kerk (the Old Church of Amsterdam) and the tutor of Rembrandt's wife, Saskia. These Mennonites had not forgotten that in 1533 the reformer Caspar Schwenckfeld affirmed an idea—utopian at the time—that the power of political authority "is obliged to act so that its subjects do not suffer violence because of their faith." Was this ecumenical thought, almost secular in its demand for tolerance, shared by Rembrandt?

Confronted with grief and ordeals, would he come to think like this "you" evoked by Spinoza: "And so they will not stop asking for the causes of causes until you take refuge in the will of God, i.e., the sanctuary from ignorance"?

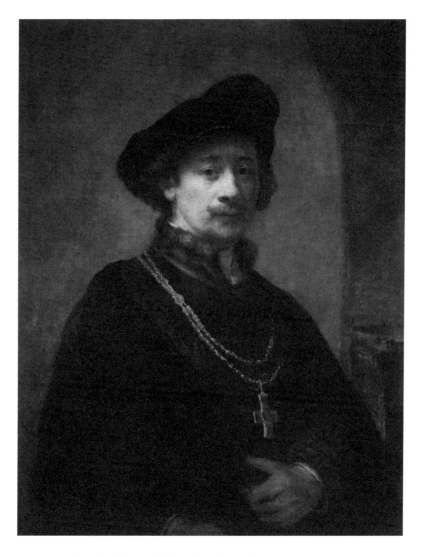

*Self-Portrait with Beret, Gold Chain, and Cross*. (1638). Oil on canvas, 94 × 74.5 cm. Traces of a signature: *Rembra*.... National Gallery of Canada.

# 21. BEGGAR AND ROGUE

Seated on a milestone, on an embankment (opposite). In rags. The torn upper of the shoe reveals the bare toes of a poor beggar's foot. Palm outstretched. Mouth open to swear, moan, or implore. Or blaspheme. A look of bitterness and anger, despair, rage, or resignation—who knows? An aggressive look. Loose-fitting, battered beret, unkempt hair and beard to match.

Another figure, this one standing, right hand resting on his hip, posture conveying status and self-assurance (page 62). The right hand holds on to the knob of a cane. An accessory for elegance, the cane goes with his embroidered silk tunic and the heavy velvet cloak draped over his shoulders. A turban adorned with a feather. A helmet on the table behind him. A thin, trimmed mustache on the upper lip.

A rogue. A *mamamouchi*. (This word is used for the first time in Chambord, where Louis XIV, accompanied by the Court, used to go hunting. It makes its debut before the public on October 14, 1670, when, in Scene 3 of Act IV of Molière's *Bourgeois Gentleman*, Covielle announces to Monsieur Jourdain that the son of the Grand Turk wants to make him such a *Mamamouchi*, "which is a great dignity in his country.")

Rembrandt is both the beggar in rags and the figure in oriental attire.

In the years 1630 and 1631, the damasks and tatters, the embroideries and the mended tears, the precious fabrics and the patched rags somehow play the same role: to prove by the etching, as well as the painting, that Rembrandt can paint everything and anything. All of it. And, therefore, all aspects of history, its miseries and its pomp. And in the process, he proves that he can capture a resemblance. Because whether he depicts himself as a poor man or a wealthy one, his features are recognizable.

Such self-portraits are sales pitches. Do you want a history painting? Rembrandt is the painter for you. You want a portrait? Rembrandt cannot fail to show your importance.

And with the portrait of himself begging, he reminds you of a higher order. Charity remains a duty, something a Christian ought not to forget. Holland is wary of poor beggars, whom it suspects to be crooks, vagrants, rogues, and scum. An intolerable threat. In the first years of the century, Leiden singled out the deserving poor for assistance and banished the rest. In 1613, Amsterdam created an institution for men, *Raphuis*, and one

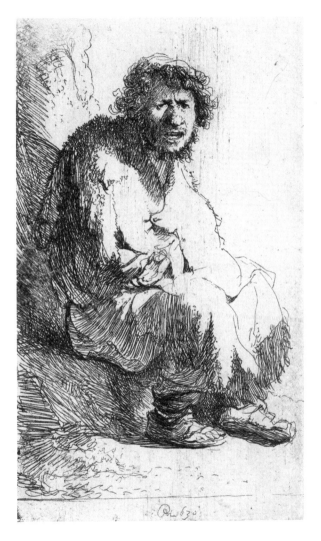

*Beggar Seated on a Bank*. 1630. B174. Etching, 1st state,
11.6 × 6.9 cm. Signature and date: *RHL 1630*. Rijksmuseum,
Amsterdam.

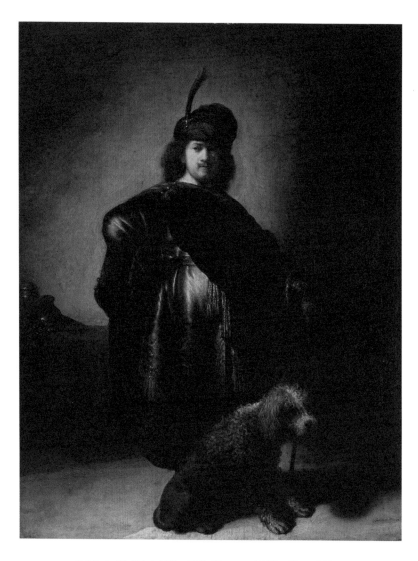

*Self-Portrait in Oriental Attire*. 1631. Oil on wood, 66.5 × 52 cm (RRP, 63 × 56 cm). Signature and date: *Rembrandt f 1631*. Petit Palais, Paris.

for women, *Spinhuis*, to put the poor back on the path of a humble and decent Christian life. As for those who were judged unworthy of such help or who refused it, the pariahs were expelled. A traveler who visited the Netherlands noted: "It is as rare to meet a beggar here as to see a horse, as they say, on the streets of Venice." Rare, very rare, were those who received permission to hold out their hands or a begging bowl in the city. And, what's more, they could only beg at designated places, often in front of the doors of a temple. Perhaps, when leaving services, the faithful might be relied upon to remember the words of Christ recorded by Matthew in his Gospel (25:35–36): "For I was hungry and you gave me something to eat, I was thirsty and you gave me something to drink, I was a stranger and you invited me in, I needed clothes and you clothed me, I was sick and you looked after me, I was in prison and you came to visit me."

If these words are enough to justify Rembrandt portraying himself as a poor man among the poor, to whom he then dedicates more than twenty etchings, he has another reason to attempt such a theme. He discovered the etchings of a series of beggars by Jacques Callot (1592–1635). Same rags, same tattered clothes, same procession of cripples with wooden legs, supported by crutches or hunched over canes. No doubt he learned that Callot's fame was such that, a few years earlier, in 1625, the Infanta Isabella-Claire-Eugénie, Isabella of Austria, who governed the Catholic Netherlands in the name of her father, Philip II, asked him to come and join her in Brussels in order to immortalize the Spanish victory in Breda. Could Rembrandt, at twenty, be showing that he, an engraver in these rebellious Calvinist United Provinces of the Netherlands, is as worthy of recognition as an artist in the service of the oppressor?

# 22. SOLITUDE

In Paris during the nineteenth century, numerous Dutch painters came for training under a compatriot, such as Gérard van Spaendonck, who had found acceptance there and was earning a living. It was in Paris that Ary Scheffer, born in Dordrecht, perfected his training in the studio of Pierre-Narcisse Guérin and pursued his career. The articles that Théophile Thoré-Bürger (1807–1869) dedicated to a forgotten painter, Johannes Vermeer, published by the *Gazette des beaux-arts* in 1866, and the book by Eugène Fromentin (1820–1876), *Les Maîtres d'autrefois* (1876), signaled renewed interest in painters from the Netherlands. Among these books was a six-hundred-page volume titled *Rembrandt, sa vie, son œuvre et son temps* (1893), by the painter Émile Michel (1828–1909), who had been elected to the Académie des Beaux-Arts a year earlier. In the last pages, he writes, lucidly, and perhaps with resignation: "When he has communicated to us through his work, captured us and held us, Rembrandt throws us back on ourselves." There is no more relevant finding. Facing the solitude of Rembrandt returns us to our own.

# 23. INDUSTRIOUSNESS

A drawing from 1630, or maybe 1635. On the left, some lines for the head of Rembrandt, who is raising his eyes to the distinctive, tall, bearskin cap that a bearded old man is wearing (page 68).

"Wherefore, as the short duration of the light ought to excite laborers to industry and toil, that the darkness of the night may not come on them by surprise, ere their exertions are well begun, so, when we see that a short period of life is allotted to us, we ought to be ashamed of languishing in idleness." This reminder of a higher order from Calvin's *Commentaries on the New Testament* was perfectly understood by Rembrandt. This shame would not be his. He works relentlessly.

This drawing, related to some project we know nothing about, is one of the signs of his obstinate and relentless toil.

Three etchings provide other signs.

*Self-Portrait with Plumed Beret*. 1630. Pen and sanguine (red chalk), brown wash with white gouache highlights, 7.2 x 8.1 cm. Signature and date: *RHL 1630*. Louvre, Paris.

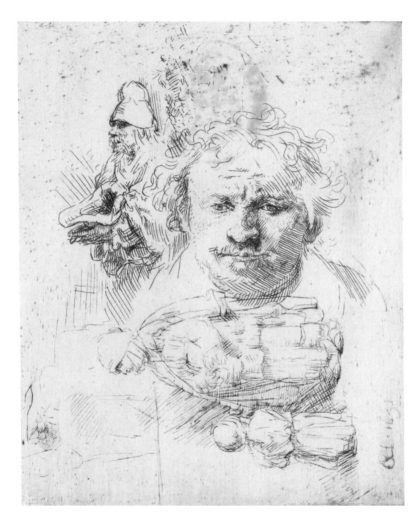

*Sheet of Studies with the Head of the Artist*. (1631 or 1651).
B370. 1st state, 11.1 × 9.2 cm. Signature and date: *RHL 1631
(1651?)*. Rijksmuseum, Amsterdam.

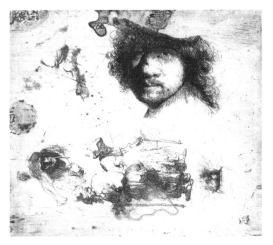

*Sheet of Studies with the Head of the Artist.* 1631. B363.
Etching, 10.1 × 11.3 cm. Signature and date: *RHL 1631.*
Rijksmuseum, Amsterdam.

*Sheet with Two Studies: A Tree and the Upper Part of a
Head of the Artist Wearing a Velvet Cap.* (1638). B372.
Etching, 1st state, 6.9 × 7.9 cm. Rijksmuseum, Amsterdam.

In the studio where he set up his press, where prints are drying on a line like wet clothes, he drew his own face beside the silhouette of a beggar on a copperplate; he turned the plate ninety degrees and sketched a peasant woman and child and signed and dated it, *RHL 1631,* in this orientation. What has he dated? The sketches of these figures? His portrait? The plate may have been picked up and put down for months (page 66).

On another copperplate that is neither signed nor dated, he makes another appearance (page 67, top). The ghost of a smile. Above his head a pale void, perhaps a stain left by the acid, evokes a beret. And, as in the previous print, perpendicular to this self-portrait are two figures, old, poor wretches leaning on their canes. Above their heads and beneath their feet are two faces whose eyes are in shadow, produced respectively by a head scarf and a cap. And on still on another plate, under the sketch of a tree: the top of his head with the missing beret, in perpendicular orientation (page 67, bottom). On either side of the furrow in his brow beneath the edge of the cap, his eyes, one slipping into invisibility.

Somehow, these etchings have been dated between 1630 and 1638. This implies that the first ones were etched in Leiden, the others after he moved to Amsterdam, at a time when he was convinced that, thanks to what would be the body of his prints, his fame would prevail beyond Holland.

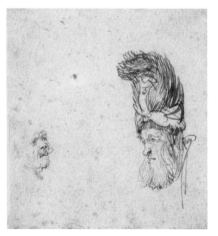

*Bearded Old Man with High Fur Cap; Self-Portrait.* c. 1635. Pen and bister, 6.7 × 5.2 cm. Morgan Library and Museum, New York.

# 24. REMBRANDT, FULL STOP

On May 5, 1631, René Descartes wrote to his friend Jean-Louis Guez de Balzac: "Whenever you have the pleasure to see the fruit growing in your orchards and of feasting your eyes on its abundance, bear in mind that it gives me just as much pleasure to watch the ships arriving, laden with all the produce of the Indies and all the rarities of Europe. Where else on Earth could you find, as easily as you do here, all the conveniences of life and all the curiosities you could hope to see?" This place is Amsterdam, where Descartes has been living for a few months. He has already had time to verify, "In this large town where I live . . . everyone but myself is engaged in trade, and thus is so focused on his own profit that I could live here all my life without ever being noticed by anyone." Rembrandt, who moves to Amsterdam that same year, is far from wanting not to be noticed, but otherwise, like Descartes, he is open to "all the curiosities" that he begins to discover.

The following year, on two occasions, he feels the need to depict himself for the bourgeoisie of Amsterdam, to whom he is offering his services. Same presentation of an impeccable young man whose hair frames his face. Same broad-brimmed black hat that shows the discreet shine of a chain that surrounds the crown; same loosely pleated ruff, a wide collar of starched lace called a *fraise à la confusion*. In the first of these self-portraits, which is signed *RHL van Ryn*, three loops, irregular ellipses describing buttonholes, alongside the buttons themselves, scatter light across the surface of his black coat (page 70). On the second portrait, another signature: *Rembrandt f* ("f" for in Latin: "he made [it]"). Below the signatures is the same date: 1632.

The first signature, *RHL van Ryn*, gives his personal identity. "R" for Rembrandt, "H" for Harmenszoon, son of Harmen, "L" for Leiden. Although perhaps he means for the monogram to be read in Latin: *Rembrandus Hermanni Leydensis*. As Albrecht Dürer signed *Albertus Durerus Noricus*. As Holbein signed *Ioannes Holpenius Basileensis*. As Poussin signed one of his portraits *Effigies Nicolai Poussini Andelyensis*.

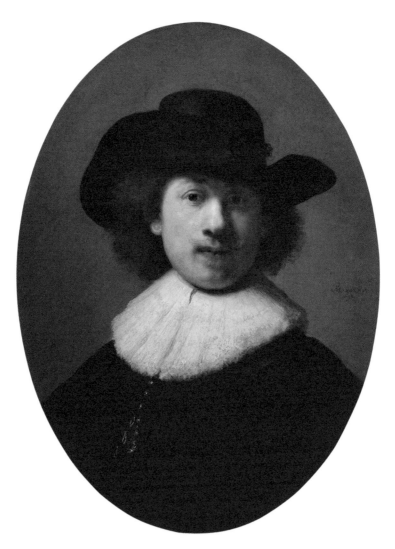

*Self-Portrait*. 1632. Oil on wood, 64.4 × 47.6 cm (RRP, 63 × 48 cm).
Signature and date: *RHL van Ryn 1632*. The Burrell Collection, Glasgow.

The second signature, *Rembrandt,* bears a different connotation. Rembrandt, when he chooses to sign with only his first name, as no other painter in the Netherlands had ever done, is indicating who his peers are. He is, and he wants to be, a Rembrandt, full stop. Who is even aware that Michelangelo bore the name of Buonarroti? Who cares that Raffaello could have been Raffaello Sanzio? Who worries that Tiziano was Tiziano Vecelli da Cador? How important is it that Leonardo is da Vinci? It is against those whose first names alone are enough to signify glory that Rembrandt intends to measure himself.

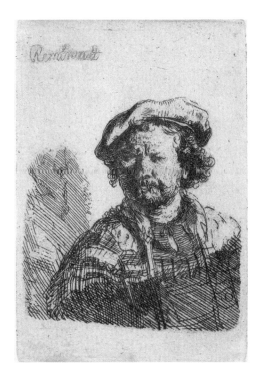

*Self-Portrait in a Flat Cap and Embroidered Dress.* (1639). B26. Etching, 9.3 × 6.2 cm. Signature: *Rembrandt f.* Rijksmuseum, Amsterdam.

# 25. AET

In 1632, Rembrandt delivered the painting that depicts an anatomy lesson given by Professor Nicolaes Pietersz Tulp (1593–1674). Since 1628, Tulp had been the *Praelector Anatomiae* of the Amsterdam Guild of Surgeons. The trust he placed in Rembrandt, age twenty-six, gave the artist access to everyone who was anyone—all those who were likely to commission their portrait.

Rembrandt was quick to let them know that he followed the advice given by Aristotle: "Since Tragedy is an imitation of persons who are above the common level, the example of good portrait painters should be followed. They, while reproducing the distinctive form of the original, make a likeness which is true to life and yet more beautiful." This he did. For himself, in a painted self-portrait to mark his status, like Tulp, he put on a black felt hat adorned with a brooch or a gold chain. The ruff is the same that he painted twice during 1632, and he also put it in an etching that he worked over again and again in state after state (opposite). On one of these, he specifies his age and the date: *AET 24, Anno 1631*.

*AET* stands for the conventional notation *Aetatis suae*, "at the age of." If Rembrandt was actually born on July 15, 1606, how could he believe that in 1631 he was still twenty-four years old, when he was actually twenty-five? Though a birth certificate or any other incontestable document has never been found, it must be acknowledged that in the book *Beschrijvinge der stad Leyden*, a history of Leiden published in 1641, Jan Jansz. Orlers (1570–1646) gives the date 1606. It's an uncertain date if we judge by other documents, such as the banns for Rembrandt's marriage to Saskia in 1634, where it is specified that he was then twenty-six years old. A notary records during an appraisal in September 1653 that Rembrandt was about forty-six years old. Could Rembrandt have been born in 1607? Likely he knows nothing specific himself about his date of birth. It may not matter much to him. On the other hand, it is important for him to show that he is no different from those who might commission their portraits, that he is their peer.

*Self-Portrait in a Soft Hat and Embroidered Cloak.* (1631). B7. Etching and drypoint, 1st state, 14.8 × 13 cm. Rijksmuseum, Amsterdam.

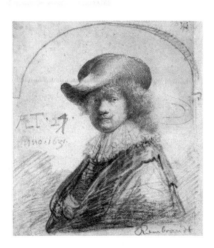

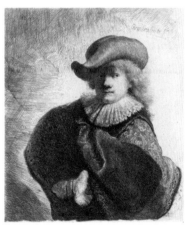

*Self-Portrait in a Soft Hat and Embroidered Cloak.* 1631. B7. Etching and drawing, 2nd state, 14.6 × 13 cm. Signature and date: *Anno 1631, Rembrandt.* British Museum, London.

*Self-Portrait in a Soft Hat and Embroidered Cloak.* 1631. B7. Etching and drypoint, 10th state, 14.8 × 13 cm. Signature: *Rembrandt f.* Rijksmuseum, Amsterdam.

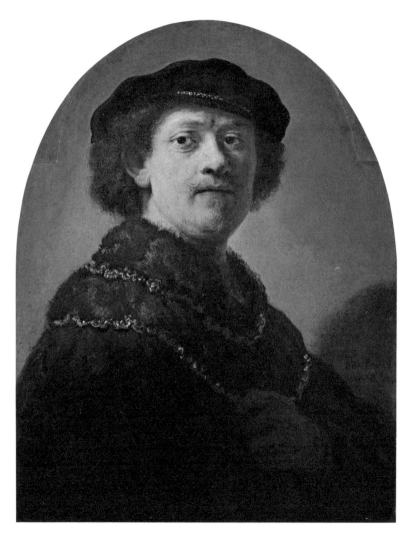

*Self-Portrait*. (1640). Oil on wood, 64 × 49 cm. Signature (possibly not original): *Rembrandt f*. The Wallace Collection, London.

# 26. METAMORPHOSIS

Paul Valéry reports these words spoken by Edgar Degas, which were repeated to him by Ernest Rouart: "We must have a high idea, not of what we do, but of what we can do one day; otherwise, it is not worthwhile to work." Such a "high idea" is Rembrandt's as soon as he begins to paint and etch and to make his self-portraits in Leiden.

Rembrandt full of himself? Foolish accusation.

He knows what he must keep to: the portraits of Protestant austerity, sitters who pose ostentatiously with a humility that has the appearance of arrogance. Can he be satisfied with painting these appearances, these impostures? He cannot abide false pretenses.

A "high idea." Bring a face to life, an impossible task and yet the only one he feels is worthy of him. Rembrandt is not satisfied with painting a portrait; he must paint a presence. That is as irrefutable and brutal as a fact. His eye and his hand—which soon know all the formulas, all the artifices and all the subterfuge, all the operations and all the sly tricks of the trade—are the foundation of his assurance. To paint oneself is to verify their power. To Descartes, who says, "I think, therefore I am," Rembrandt replies, "I paint, therefore I am." Or, rather, "I paint, and I am only what I paint. I, Rembrandt, am and I am only this portrait." If he turns so often to a mirror, it is not for confidence, nor to make an admission or confession. The *self* that is his has nothing to do with the indulgence of introspection. He works tirelessly, rather, to assert the proud power of a *self* where everything ends and from which everything emanates.

He goes from drawing to etching, from etching to painting, from painting to drawing, and then back to etching again, gradually realizing that his only reality is his work. Rembrandt never painted Rembrandt except to become *a* Rembrandt.

# 27. THE CROSS

Standing, wearing a blue beret in bright light and silhouetted in front of the neck of a light-colored horse, Rembrandt, who has grabbed the wood on which the feet and hands of Christ have just been nailed, is among the executioners who raise the Cross (opposite). An inscription is nailed to the wood above Christ, as reported in the Gospel of John (19:19–20): "And Pilate wrote a title, and put it on the cross. And the writing was JESUS OF NAZARETH THE KING OF THE JEWS. This title then read many of the Jews: for the place where Jesus was crucified was nigh to the city: and it was written in Hebrew, and Greek, and Latin." Matthew records (27:37) only these words: THIS IS JESUS THE KING OF THE JEWS. And Mark (15:26), even more concisely: THE KING OF THE JEWS. In the *Descent from the Cross*, which he etched a year later, this inscription disappeared, but Rembrandt is still present (page 78). Standing on a ladder, he holds the left arm of the dead Christ. Only a few rays of light illuminate the scene; behind them is darkness. These are the words according to Matthew (27:45): "Now from the sixth hour there was darkness over all the land unto the ninth hour." Mark (15:33): "And when the sixth hour was come, there was darkness over the whole land until the ninth hour."

Rembrandt has reasons for depicting himself in the *Raising of the Cross* and in the *Descent from the Cross*.

The first is his faith. How could he not be convinced by the certainty of Calvin that Christ died for the sinner? Sinner and, therefore, guilty, he must, by reason of this guilt, count himself among the executioners of Christ. And perhaps this poem by Jakob Reefsen, alias Jacobus Revius (1586–1658), was a prayer for him:

> I am the one, O Lord, who brought you there,
> I am the heavy cross you had to bear,
> I am the rope that bound you to the tree,
> The whip, the nail, the hammer, and the spear,
> The blood-stained crown of thorns you had to wear:
> It was my sin, alas, it was for me.

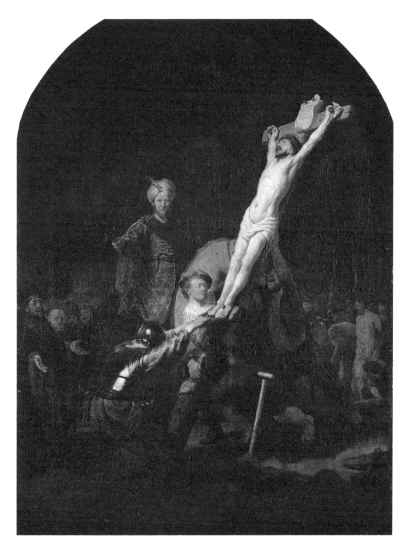

*The Raising of the Cross*. 1634. Oil on canvas, 96.2 × 72.2 cm.
Alte Pinakothek, Munich.

*The Descent from the Cross*. 1633. B81. Etching, 1st state, 53 × 41 cm.
Signature and date: *Rembrandt f cum pryvL*. *1633*. Rijksmuseum, Amsterdam.

The second is a conviction that must have been acknowledged by Constantijn Huygens, to whom Rembrandt writes in February 1636: "My Lord, my gracious Lord Huygens, I hope that Your Lordship will inform His Excellency that with great diligence I am in the process of completing as quickly as possible the three paintings of the Passion that His Excellency himself has commissioned me to make: an Entombment, Resurrection, and Ascension of Christ, to accompany a *Raising of the Cross* and a *Descent from the Cross*."

His Excellency is Frederick Henry, Prince of Orange-Nassau, a stadtholder whose secretary is Huygens. Neither Huygens nor Frederick Henry must doubt the talent of a painter who countersigns his work with a portrait of himself. Such a self-portrait—called *in assistenza* when the painter depicts himself as witness to a historical scene—only confirms his place in a tradition that allowed Masaccio to depict himself as Saint Peter in the Chapelle Brancacci de Santa Maria del Carmine in Florence, Raphael to be present in *The School of Athens*, and Dürer to include himself amid a crowd, holding a placard bearing his signature, in *The Martyrdom of the Ten Thousand*. Citing all the innumerable altarpieces, frescoes, and paintings where self-portraits are found would be impossible. To depict himself in the painting intended only for the stadtholder and in an etching whose copies would be acquired by more numerous art buyers, Rembrandt affirms that he wants to be the peer of these painters whose names are shrouded in glory.

# 28. SINNER

The first state of this print, which leaves no room for emptiness, is dated 1635. The second state is dated 1636 (opposite). A variation of a grisaille painted in oil in 1634 (page 82), it is Rembrandt's most important etching since he started working on copper. It owes its title, *Ecce Homo* (Behold the man), to the words spoken by Pilate as quoted in the Gospel According to John (19:5): "Then came Jesus forth, wearing the crown of thorns, and the purple robe. And Pilate saith unto them, 'Behold the man!'"

The occasion is narrated by Luke (23:13–14 and 23:16–23): "And Pilate, when he had called together the chief priests and the rulers and the people, Said unto them, 'Ye have brought this man unto me, as one that perverteth the people: and, behold, I, having examined him before you, have found no fault in this man touching those things whereof ye accuse him: No, nor yet Herod: for I sent you to him; and, lo, nothing worthy of death is done unto him. I will therefore chastise him, and release him.' (For of necessity he must release one unto them at the feast.) And they cried out all at once, saying, 'Away with this man, and release unto us Barabbas' (who for a certain sedition made in the city, and for murder, was cast into prison.) Pilate therefore, willing to release Jesus, spake again to them. But they cried, saying, 'Crucify him, crucify him.'"

The gestures speak for themselves. Pilate's outstretched hand confirms that he has no motive for condemning the man crowned with thorns, who, with bound hands, is standing on the steps of the palace, presented to the people who push forward, restrained by the soldiers. One of the high priests or one of the chiefs leans toward the crowd with one hand raised to restrain the people from shouting the name of Barabbas. It is early. Pilate has not yielded yet. Behind a halberd, a man with wide eyes wearing a beret leans forward. He does not want to miss anything that is said. Rembrandt.

In *The Wedding Feast of Samson*, Rembrandt takes his position behind Samson, who has just spoken at his wedding (page 83). A story in the Book of Judges (14:11–14) reports: "And Samson said unto them, 'I will now put forth a riddle unto you: if ye can certainly declare it me within the seven days of the feast, and find it out, then I will give you thirty sheets and thirty change of garments. . . .' And they said unto him, 'Put forth thy riddle, that we may hear it.' And he said unto them, 'Out of the eater came forth meat,

*Ecce Homo* or *Christ Presented to the People*. 1636. B77. Etching, 55.1 × 44.8 cm. Signature and date: *Rembrandt f 1636 cum privile*. Bibliothèque nationale de France, Paris. The circle indicates Rembrandt's self-portrait.

*Ecce Homo* or *Christ Presented to the People*. 1634. Oil on paper mounted on canvas, 54.5 × 44.5 cm. National Gallery, London. The circle indicates Rembrandt's self-portrait.

and out of the strong came forth sweetness.'" Rembrandt, wearing a plumed birretta, strains his ear behind Samson, whose raised fingers confirm and enumerate the proposal he is making.

Not far from Christ, whose sentence Pilate is going to pronounce, Rembrandt counts himself among the sinners. Does he identify himself in *The Wedding Feast of Samson* with the Philistines gathered together at Timnah? Why? Or does he want his presence, once again in a history painting, to countersign a painting signed and dated *Rembrandt f 1638*? Questions without answers.

*The Wedding Feast of Samson*. 1638. Oil on canvas, 126.6 × 174.7 cm.
Signature and date: *Rembrandt 1638*. Gemäldegalerie Alte Meister, Dresden.
The circle indicates Rembrandt's self-portrait.

# 29. THE ORIENT

At what merchant's, what shipowner's—perhaps of the United East India Company—has Rembrandt found this unique weapon (below)? Perhaps he has been assured that this curved dagger with the wavy blade is a *kris* from Malaysia. This weapon finds its place among the exotic objects of all kinds that he has begun collecting. There are two Indian cups, an East Indian powder-box, a Japanese helmet, a negro lifecasting, two porcelain cassowaries, a latticework shield, a hammock with two calabashes (or bottle gourds), one of which is made of copper, etc.—objects that were scrupulously catalogued in July 1656, when an inventory of his property was made. They are props for staging the historical episodes he paints, as well as for the composition of extravagant self-portraits. Why did he engrave such unusual, bizarre, and preposterous self-portraits? For what reason if not to surprise, even at the risk of disconcerting? For what reason, if not to fire the imagination of Amsterdam, which owed its power and fortune to the United East India Company? Rembrandt in an oriental getup, adorned with an ermine collar, with a narrow gorget on his chest, or wearing a beret pushed down on his forehead, with a curving feather at the side, or a cap decorated with a feather bush attached with a brooch is not a character of any scene from the Bible or from ancient history. But that is of no importance, because (perhaps) the essential *raison d'être* of these self-portraits is to assert his freedom.

*Self-Portrait with Raised Sabre*. 1634. B18. Etching, 12.4 × 10.8 cm. Signature and date: *Rembrandt 1634*. Bibliothèque nationale de France, Paris.

# 30. THE PRODIGAL SON

Luke (15: 11–13): "A certain man had two sons: And the younger of them said to his father, 'Father, give me the portion of goods that falleth to me.' And he divided unto them his living. And not many days after the younger son gathered all together, and took his journey into a far country, and there wasted his substance with riotous living." This narrative haunts and frightens the industrious, opulent Holland. In Amsterdam, in the warehouses and on the docks, in the attics as on the canal quays, bales are piled up; their perfumes evoke distant outposts. The parsimonious virtue of men who are up-and-coming and thrifty, daring but rigorous, sober and puritanical, requires a decent life lived between the temple and the stock exchange. But the tavern and the brothel are not far away.

Although Luke does not say anything about the way in which this prodigal son dissipated his property, it did not take long for the popular imagination to invent scenes not mentioned by the evangelist. Free and rich, on the very evening of his departure, the young man stops at an inn and throws savings, effort, and chastity out the window. Drinking wine. Feasting. Whoring. The next day, hungover and sober again, exhausted, plundered, he has nothing left. To a moralist, this story underscores the danger of debauchery and dissipation and upholds the virtues of self-control and thrift that are required to manage a fortune with care and save one's soul.

Would Rembrandt, who depicts himself as the prodigal son, have any truck with these virtues? And how did he dare to give the courtesan sitting on his knees the features of his wife, Saskia (page 86)? Had he no sense of honor and respect? What is the meaning of such a provocation? In a letter of December 28, 1885, to his brother Theo, Vincent van Gogh writes, in reference to a woman's portrait by Rembrandt that he has just discovered: "The expression a mysterious smile like that of Rembrandt himself in his own portrait where Saskia sits on his knee and he has a glass of wine in his hand." The purpose of such a painting is just as mysterious as that smile.

A few weeks before his marriage to Saskia van Uylenburgh in Sint Annaparochie, in Friesland, on July 2, 1634, in an *album amicorum* in which a visitor asked him for a record of their meeting, Rembrandt wrote this precept: *Een vroom gemoet acht eer boven goet* ("A pious man puts honor above material goods"). The respectable affirmation gives

*Rembrandt and Saskia in the Parable of the Prodigal Son* or *Self-Portrait with Saskia (The Prodigal Son)*. c. 1635. Oil on canvas, 161 × 131 cm. Gemäldegalerie Alte Meister, Dresden.

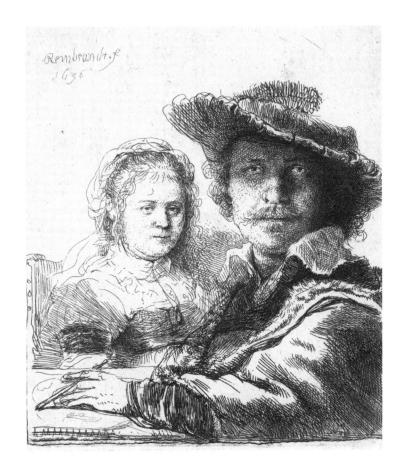

*Self-Portrait with Saskia*. 1636. B19. Etching, 10.4 × 9.5 cm. Signature and date: *Rembrandt f 1636*. Rijksmuseum, Amsterdam.

no clue that the writer will, a few months later, depict himself as such a prodigal indulging in debauchery.

Rembrandt first met Saskia at the home of her cousin Hendrick van Uylenburgh, who was a dealer in paintings and etchings, when he visited Amsterdam in 1631. Saskia had lost her mother when she was seven, her father five years later. The inheritance that her father, Rombertus, left her, which had to be shared among his four daughters, was managed by her cousin Aelje, wife of the minister Johannes Cornelisz Sylvius. Saskia's education had taught her to be pious, austere, and thrifty. How, then, could her husband allow himself to make a courtesan of her, a prostitute, in the only painting where he depicts himself with her? Did he have some arbitrary desire to shake up conventions and proprieties? Some have assumed that he was responding to criticism with such a masquerade. He was suspected of squandering his young wife's money by buying a house in 1638 on Sint Antoniesbreestraat, where the couple settled the following year. Malicious gossip, scandal, defamation? An uncertain hypothesis. Or, another hypothesis. This is a man who painted himself at the foot of the Cross, a sinner among the sinners responsible for the death of Christ, who was sacrificed for them. Could he have wanted—brandishing a glass over a table on which appears a peacock, a symbol of vanity—to deliver a warning? That it only takes one misstep to fall into debauchery? And sins must be enumerated on the slate hung on the wall? Who is this Rembrandt, whom Paul Claudel, in *The Eye Listens* (1946), describes as "hilarious, with his sword on his side and disguised as a gentleman, with one hand hugging a compliant and satisfied Saskia, and the other raising to the ceiling a long glass filled with a luminous wine, as though raising a toast to the ideal"?

A history painting, certainly, because the parable of the prodigal son reported by Luke is the source of the painting, but also a double portrait, because the models depicted are his wife and himself. Rembrandt is blurring the frontiers between genres. It's out of the question to doubt that this was deliberate.

# 31. THE HELMET

For the first and last time, Rembrandt depicted himself wearing a helmet (page 90). Although it is adorned with a feather that goes up to its crest, it is hardly different from the one he painted in 1631, which is found on a table behind him in his *Self-portrait in Oriental Attire* (page 62). Between the folds of the huge cloak draped around him, a gorget on the upper part of his chest is visible. What is the reason for wearing this paraphernalia? To offer proof that he is no different from those men who are part of the militia? Or—another hypothesis, equally unverifiable—to invite whoever looks at this portrait to remember these words of the apostle Paul, in his First Epistle to the Thessalonians (5:8): "But let us, who are of the day, be sober, putting on the breastplate of faith and love; and for an helmet, the hope of salvation"?

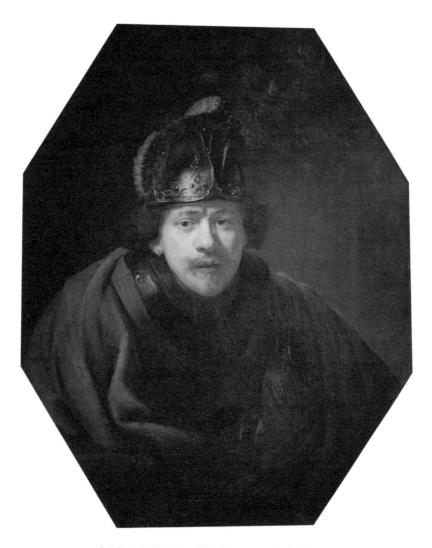

*Self-Portrait with Helmet*. 1634. Oil on canvas, 80.5 × 66 cm.
Signature and date: *Rembrandt f 1634*. Gemäldegalerie Alte
Meister, Kassel. With interpolations by the studio?

# 32. ROMANTIC REMBRANDT?

On July 19, 1879, Vincent van Gogh wrote to his brother Theo: "I know no better definition of the word *Art* than this, 'Art is man added to nature,' nature, reality, truth, but with a meaning, with an interpretation, with a character that the artist brings out and to which he gives expression, which he sets free, which he unravels, releases, elucidates." Four years later, on July 11, 1883, he returns to his certainty: "The principle of 'man added to nature' is needed more than anything else in art, and one finds the same thing in Rembrandt's portraits, for example—it's more than nature, more like a revelation."

In a letter he sent to van Gogh in Arles a few days earlier, Émile Bernard thought it best to copy the quatrain from the poem "Les Phares," where Baudelaire wrote:

> Rembrandt, sad hospital that a murmuring fills,
> Where one tall crucifix hangs on the walls,
> Where every tear-drowned prayer some woe distils,
> And one cold, wintry ray obliquely falls.

On July 29, 1888, Vincent replied: "Ah . . . Rembrandt . . . all admiration for Baudelaire aside—I venture to assume, especially on the basis of those verses . . . that he knew more or less nothing about Rembrandt." Vincent underscored his point the next day in a new letter: "Let Baudelaire hold his tongue in this department, they're resounding words, and how hollow!!! Let's take Baudelaire for what he is, a modern poet just as Musset is another, but let them leave us alone when we're talking painting."

Théophile Gautier, the "impeccable poet" to whom Baudelaire dedicated his *Fleurs du Mal*, assured him: "Rembrandt is a romantic genius in the strongest sense of the word, an alchemist of color, a magician of light."

"Romantic" Rembrandt—this singular misunderstanding is underscored by Gautier's description of "three or four portraits [in the Louvre] which represent [Rembrandt] at different periods of his life. He liked to take himself for a model, and he has multiplied his portrait under different aspects. Every one of these pictures, in which he is arrayed in fantastic taste—doublets of velvet whereon golden chains scatter luminous points, linen

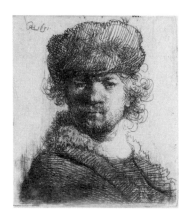

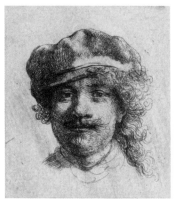

*Self-Portrait in a Heavy Fur Cap*. 1631. B16. Etching, 1st state, 6.3 × 5.7 cm. Signature and date: *RHL 1631*. Rijksmuseum, Amsterdam.

*Self-Portrait Wearing a Soft Cap*. (1634). B2. Etching, 5 × 4.4 cm. Rijksmuseum, Amsterdam.

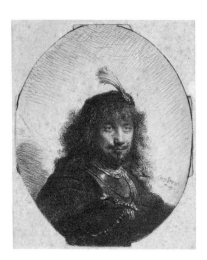

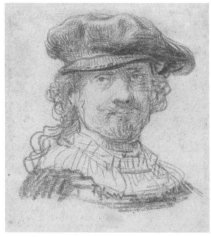

*Self-Portrait with Plumed Cap and Lowered Sabre*. 1634. B23. Etching, 2nd state, 13 × 10.8 cm. Signature and date: *Rembrandt f 1634*. Metropolitan Museum of Art, New York. H. O. Hevemeyer Collection, Bequest of Mrs. H. O. Havemeyer, 1929.

*Self-Portrait*. (1639). Sanguine (red chalk), 12.9 × 11.9 cm. National Gallery of Art, Washington. Rosenwald Collection.

showing its golden whiteness through some opening, toques, the aigrettes fastened with a gem—are incomparable masterpieces, wonders of modeling, color, and life; but the handsomest is perhaps the serious, pale young man whose oval face is framed in by long hair such as the Romanticists of 1830 used to wear. Never has Rembrandt attained greater nobility than in this handsome head with its romantic charm."

Rembrandt, with his "long hair," associated with the Romantics by Théophile Gautier. This is a prodigious anachronism. But we must be careful not to laugh, because it highlights an essential fact: Rembrandt never stops being contemporary. This implies that we will not know him or recognize him in the same way century after century. This suggests that the comments that have been made tell us more about the person writing them than about what was seen. This invites humility as well as modesty in the face of the "revelations" (I repeat the word of Vincent van Gogh) that are the self-portraits of Rembrandt. This requires sticking—at best—to conjectures and hypotheses, while keeping in mind this resigned remark by Fromentin: "I do not see the need to dig into a work already so profound and to add a hypothesis to so many hypotheses."

# 33. EARRINGS

Several times Rembrandt adorns himself with an earring (pages 104 and 130).

Men have worn this ornament for centuries. No one who posed for Rembrandt wears one, not even the naval officer, Joris de Caullery, whose portrait is signed and dated *RHL van Rijn 1632.* And yet, in the Netherlands, in Amsterdam, such ornaments appear in the ears of sailors. Custom dictated that such a loop attested that the wearer had crossed the equator. Some believed that a pierced ear would enhance a sailor's night vision. And still others said that if a sailor were to die far from his homeland, the gold bauble could be sold, allowing him to have a decent burial in a far-off outpost.

There are so many reasons that Rembrandt could have portrayed himself thusly. And (perhaps) he only added the earring, whose meaning remains indecipherable, to punctuate these portraits with a burst of light.

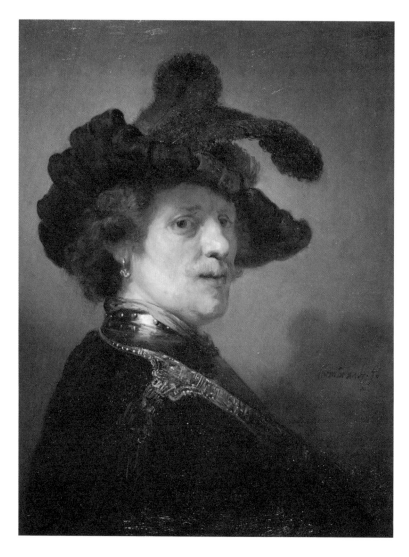

*Self-Portrait with a Feathered Beret*. c. 1635. Oil on wood,
62.5 × 47 cm. Signature: *Rembrandt f*. Mauritshuis, The Hague.

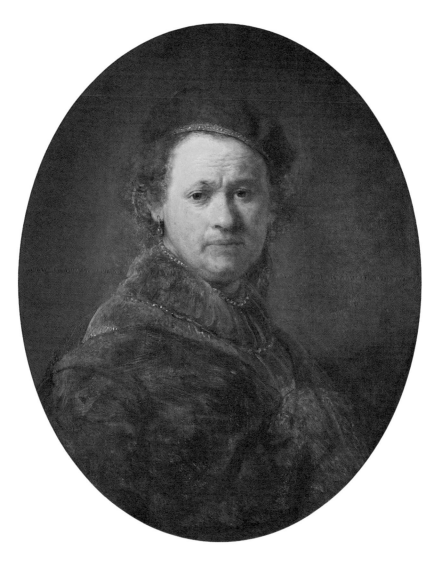

*Self-Portrait with Beret and Red Cloak*. (1643). Oil on wood, 69 × 56 cm
(RRP, 73.5 × 59.6 cm). Staatliche Kunsthalle Karlsruhe, Germany.

# 34. WEALTH

The velvets, chains, damasks, furs, and turbans he wears, which were, perhaps, found in some trading outlet of the port or in a thrift shop; the weapons he brandishes; the lace collars, which fall over his doublets; and the feathers that adorn the hats leave no room for doubt. Rembrandt is rich.

In his book on Netherlandish painting, *De groote schouburgh der Nederlantsche konstschilders en schilderessen,* published between 1718 and 1721, Arnold Houbraken (1660–1719) thought it necessary to report, with disparaging perfidy, that Rembrandt would have been eager to pick up from the floor the coins that some of his pupils had mischievously painted there. We can do without such gossip.

But let us not doubt that he coveted material things. He did not hesitate to speculate. An example: In October 1631, for a little over 424 guilders, he acquired a *Hero and Leander* painted by Rubens. Seven years later, he sold the painting for 530 guilders.

Houbraken says again, in another mockery, that Rembrandt had "so many pupils, each of whom paid him a hundred guilders a year, that Joachim von Sandrart, who knew him personally, asserted that he could calculate that Rembrandt derived an annual income from his teaching activity of more than 2,500 guilders." That would have been far from enough for him.

His etchings provided him incomparable earnings. Houbraken is quick to point to Rembrandt's cunning: "These works gave him great fame and significant earnings, especially since he made slight variations or additions to his etchings and would sell them as if they were part of a new series." Filippo Baldinucci states: "Thanks to his prints he became very rich, and along with it came such mounting pride and self-satisfaction, it seemed to him that his etchings were not sold at the prices they really deserved. He resorted to a method he came up with to increase universally the desire for his prints: at an extraordinary cost, he bought them back throughout Europe, everywhere he could find them, at any price. Among other things, he bought a fifty-guilder *Resurrection of Lazarus* at an auction in Amsterdam, while he still possessed the etched copperplate. This wonderful idea made him spend his fortune to the point that he was in the most dire straits; and something happened to him that few painters knew about: he went bankrupt."

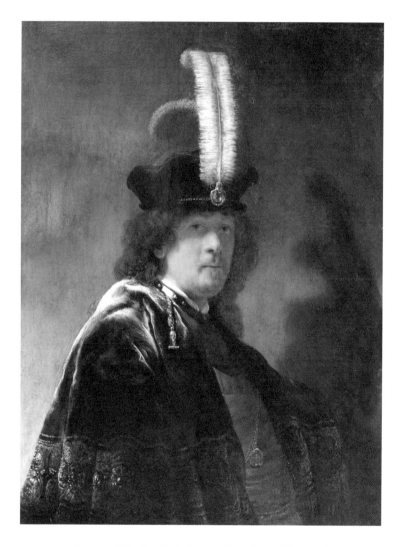

*Self-Portrait Wearing a White Feathered Bonnet*. 1635. Oil on wood, 92 × 72 cm (RRP, 90.5 × 71.8 cm). Signature and date: *Rembrandt f 1635*. Buckland Abbey, Devon, National Trust.

Baldinucci's explanation of the expenses that led Rembrandt to ruin is simple: "He held his art in such high esteem that whenever anyone told him that something was put up for auction—for example, paintings and drawings by great artists—he made an offer so high that no one could outbid him; and he said he was doing this to increase the prestige of his profession."

# 35. STANDARD-BEARER

Cap adorned with a feather, puff sleeves like those worn a few decades earlier, gorget around the neck, a sumptuous dagger at his side, Rembrandt, whose hair falls on the back of his neck, is a standard-bearer, a place of honor in a militia (opposite). According to Carel van Mander, "Painters dreamed up ambitious fictions they were obliged to portray." Rembrandt probably knew that Peter Paul Rubens had said that portraiture is only a "means—very unworthy indeed—to get the opportunity to do much more important works."

The hand turned to rest on the hip is a cliché. Standard-bearers in the same style are found at the banquet tables of militias by Frans Hals, Nicolaes Eliasz. Pickenoy, Govert Flinck, Evert van der Maes, Hendrick Pot, and others. It is always a sign of self-assurance, if not arrogance and smugness or haughtiness and insolence. There is nothing on the ecru flag, barely decorated with embroideries, whose shaft Rembrandt is holding, no coat-of-arms or insignia, to indicate what militia, guild, or city it represents.

Note the play of light and shadow in this painting, where ochres and earthen colors exclude the others. Is this chiaroscuro the real purpose of such an "ambitious fiction"?

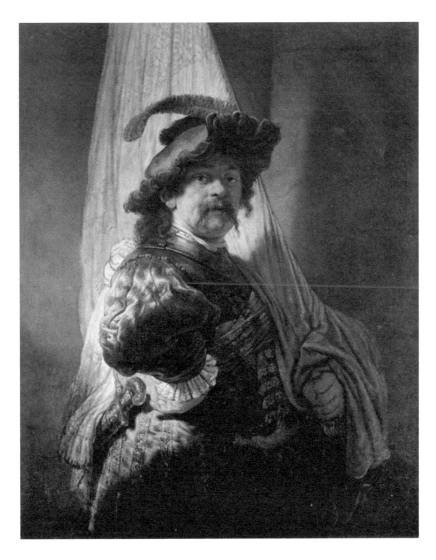

*The Standard Bearer*. 1636. Oil on canvas, 125 × 105 cm (RRP, 118.8 × 96.8 cm).
Signature and date: *Rembrandt f 1636*. Private collection.

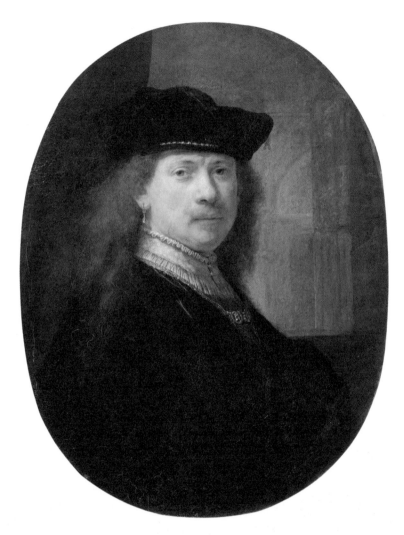

*Rembrandt in a Fur Cap with Architecture in the Background.*
1637. Oil on wood, 80 × 62 cm (oval) (RRP, 80.5 × 62.8 cm).
Signature and date: *Rembrandt f 1637*. Louvre, Paris.